NOW THAT'S WHAT I CALL DURHAM

Michael Richardson

Michael Richardson

AMBERLEY

ACKNOWLEDGEMENTS

So many people have donated and loaned photographs to the Gilesgate Archive that it is impossible to thank them all. Special thanks go to Mr John Bygate, Mrs Linda Flanagan, Mr Ian Forsyth, Mr John Hanson, the late Peter Killian, Mr Chris Lloyd, Mrs Susan Loscombe, Miss Dorothy M. Meade, Mr Derek Middlemass, Mr George Robert Savage Nelson, Mr Alan Pepper, Miss Emma Richardson, Mrs Norma Richardson, the late Mr Jack Stanton, Mrs Janet Thackray, the late Alan Wiper and Mrs Sybil Margaret Wiper. Also thanks to Clayport Library (reference section), the Dean and Chapter Library and the History of Durham Project

If any readers have any new material, photographs, slides, negatives or information they should contact:

Gilesgate Archive
C/O Michael Richardson
128 Gilesgate
Durham
DH1 1QG
Email: gilesgatearchive@aol.com
Telephone: 0191 3841427

First published 2018

Amberley Publishing
The Hill, Stroud, Gloucestershire, GL5 4EP
www.amberley-books.com

Copyright © Michael Richardson, 2018

The right of Michael Richardson to be identified as the Author of this work has been asserted in accordance with the Copyrights, Designs and Patents Act 1988.

ISBN 978 1 4456 8029 3 (print)
ISBN 978 1 4456 8030 9 (ebook)

British Library Cataloguing in Publication Data.
A catalogue record for this book is available from the British Library.

Origination by Amberley Publishing.
Printed in Great Britain.

INTRODUCTION

Now That's What I Call Durham covers the period from the 1960s to the 1980s. This was a time when drastic changes were taking place, altering the landscape of this cathedral city forever. A new through road (first discussed in the 1920s) was finally started, bringing about a massive blow to the business premises, especially those in Claypath. New bridges were constructed for the road system, along with Milburngate House (phases one and two) and later a new County Hall to replace the Shire Hall in Old Elvet.

In the 1970s more new roads (and a bridge) were constructed, one linking New and Old Elvet to Leazes Bowl Roundabout and the other from Milburngate Roundabout to North Road. Milburngate Shopping Centre (phase one) was built along with the multistorey car park off Claypath (now the site of the Prince Bishops Shopping Centre). Many of these buildings lacked character, and thankfully most have since been demolished. One exception (in my opinion) is Ove Arup's concrete Dunelm House and Kingsgate Bridge, which from the riverside fits in pleasingly, with its terraced roof and the slender design of the adjoining footbridge.

You will notice attention has been made to try and identify vehicles of the time (now all classics in themselves). The business premises covered show that Durham once had a rich variety of independent retailers, of which only a handful survive today. The World Heritage Site cathedral, castle and Palace Green have changed very little and a selection of images have been included.

In recent years student accommodation blocks have been built in and around the city, so optimistically some houses may in the future revert back to family homes. This will hopefully bring about an even balance of students and locals.

The last section shows images from Sherburn Hill and village taken by the late Billy Longstaff, an ex-coal miner and model engineer from Sherburn village.

As you look through the book you will notice the many changes that have taken place. No doubt these images will stir up happy memories of times past.

Michael F. Richardson, 2018

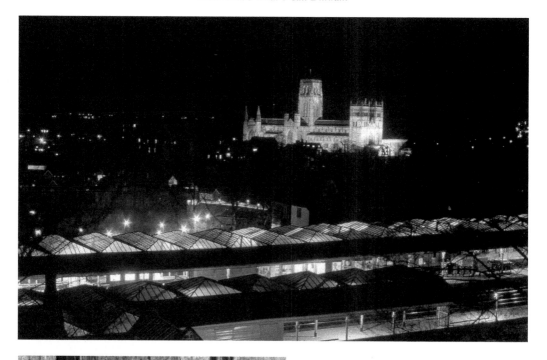

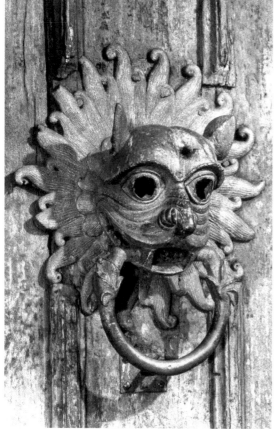

Above: The floodlit Durham Cathedral photographed in August 1964. The occasion was the Festival of Light and Sound, which attracted over 37,000 visitors to the cathedral. Looking over the railway station from Wharton Park, the photo shows the southbound Victorian platform canopy that was removed in the 1970s. (Taken by Alan Wiper)

Left: The original twelfth-century bronze sanctuary knocker on the north door of Durham Cathedral in the 1970s. In the form of a lion's head, it would have originally had glass eyes; the handle depicts a double-headed serpent. It was removed in December 1977 and sent to the British Museums Conservation Department, returned in 1980 and placed on display in the cathedral treasury. The one we see today on the door is an exact replica made at a cost of £3,000. The right of sanctuary was abolished during the reign of James I in 1623. (Taken by Alan Wiper)

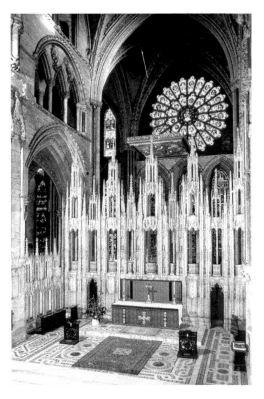

The high altar, Durham Cathedral, *c.*
1966. The ornate Neville Screen (1380)
was constructed in France and is made
of Caen stone from Normandy. It divides
the cathedral choir from St Cuthbert's
feretory. The Clayton & Bell rose window
(*c.* 1876) depicts Christ in Majesty,
surrounded by the twelve Apostles and
the twenty-four elders, 'Revelation,
chapter 4'. (Taken by Alan Wiper)

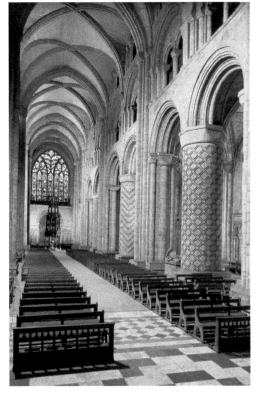

Looking down the cathedral chancel,
c. 1969, towards the east window and
the cathedral font and canopy of 1663.
It stands over 12 metres high and was
commissioned by Bishop John Cosin.
Note the distinctive carved lozenge and
zigzag decoration of the nave columns.
(Taken by Alan Wiper)

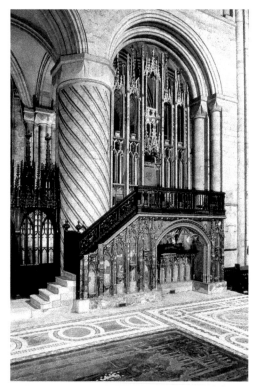

The bishop's ornate throne in the chancel area situated above the tomb of Bishop Thomas Hatfield (Bishop of Durham 1345–81), 1970s. The throne was intentionally constructed to be higher than the seat of the pope. In the foreground is the large ornamented brass inserted in 1951 to replace the original in memory of Bishop Beaumont (d. 1333), which was removed during the Reformation. The brass is usually covered by a carpet. (Taken by Alan Wiper)

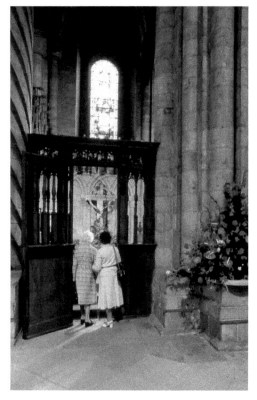

Two visitors peer into the Durham Light Infantry Memorial Chapel in 1979. They are looking towards the wooden cross that had been erected on the Butte de Warlencourt, France, to commemorate those who had fought and died at that spot. The chapel was dedicated by Bishop Henley Henson on 20 Oct 1923. (Taken by Ian Curry)

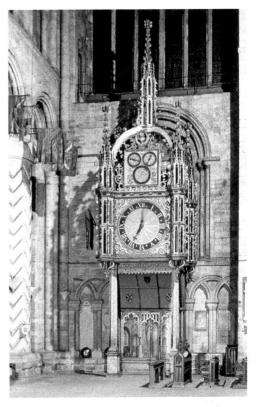

The cathedral clock in the south transept, erected in the time of Prior Castell (1494–1519), photographed in the 1970s. The clock remained in situ right up until 1845 when it was dismantled. It had survived the Scottish prisoners who were housed here after the Battle of Dunbar in 1650, possibly because of the Scottish thistle emblem carved near the top, but more likely because it was useful to know the time. The clock was restored in 1938 and returned. (Taken by Alan Wiper)

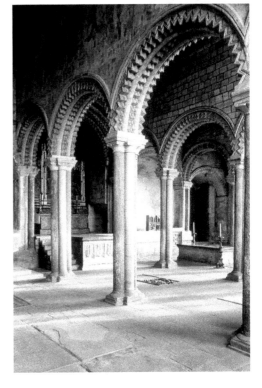

The arcades of the twelfth-century Galilee Chapel (late Norman) and the tomb of the Venerable Bede in the 1970s. Traces of medieval wall decorations can be seen. These had been whitewashed over during the Reformation (begun by Henry VIII in 1534). (Taken by Alan Wiper)

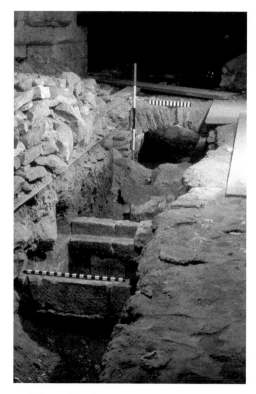

Archaeological work, *c.* 1967, being carried out on the tomb of Lord John Neville (d. 1388) and his wife, Maude Percy, daughter of Harry 'Hotspur' Percy. The vault is located in the south aisle of the cathedral nave. (Taken by Alan Wiper)

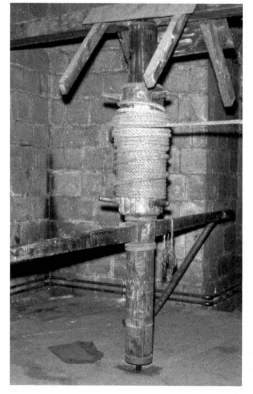

The ancient wooden hand-operated winch in the south-east turret of the cathedral, *c.* 1968. This was used to lift heavy items up to the triforium for storage. (Taken by Alan Wiper)

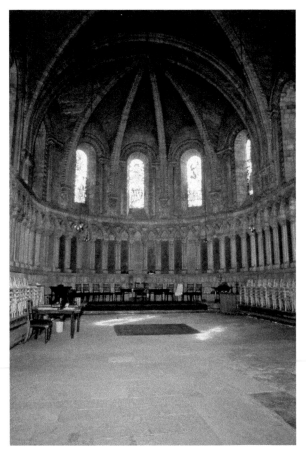

Right: The twelfth-century Chapter House, Durham Cathedral, *c*. 1966. In 1796 architect James Wyatt had the east end demolished on the grounds that it was structurally unsound. (Almost 100 years later, it was rebuilt.) This was where the bishop, prior and senior lay officials met twice daily to discuss the running of the priory. (Taken by Alan Wiper)

Below: The Monks' Dormitory (rebuilt around 1400) in the west wing of the cloisters, *c*. 1966. The bookcases date from the mid-nineteenth century. It now forms part of the 'Open Treasure' exhibition. (Taken by Alan Wiper)

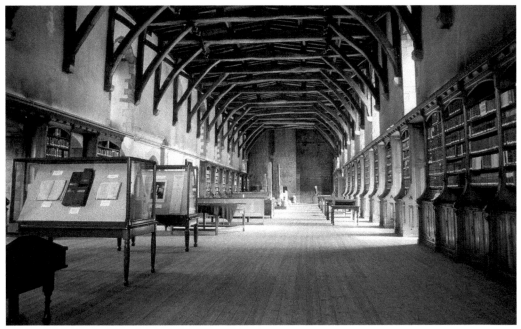

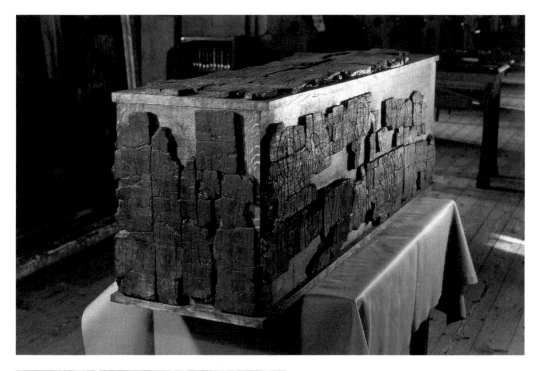

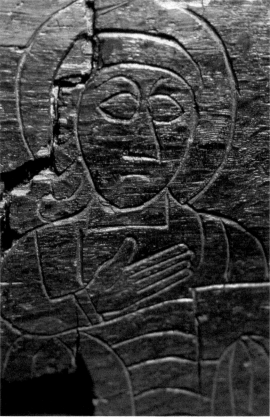

Above and left: St Cuthbert's oak coffin on display in the Monks' Dormitory, *c.* 1967. This was made in AD 698 after it was discovered that the saint's body remained incorrupt, eleven years after his death. It is decorated with images of Christ, the Virgin and Apostles and Archangels. Made of 0.75-inch thick oak, this was the inner coffin, which was encased in two others, a very rare survival of Anglo-Saxon woodwork. It is now the centrepiece of the Open Treasure project displayed in the Medieval Great Kitchen. (Taken by Alan Wiper)

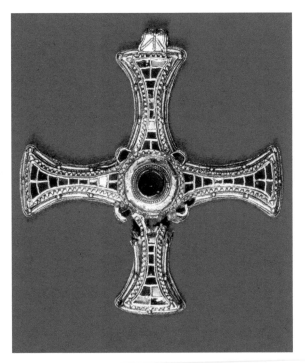

The gold and garnet pectoral
cross belonging to St Cuthbert,
c. 1968. It dates from the second
half of the seventh century
and was found hidden among
garments close to the saint's body
when his tomb was opened by the
Revd James Raine in May 1827.
(Both taken by Alan Wiper)

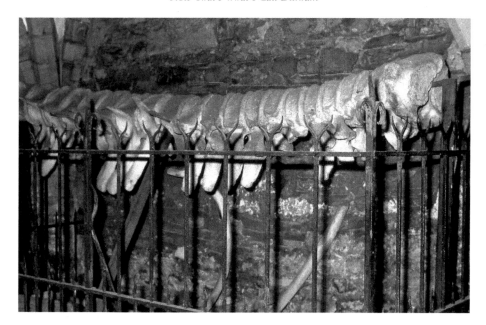

The whale bones displayed in the thirteenth-century undercroft, *c.* 1972. These bones were brought to the city in 1776. The bishops had the privilege of claiming all whales that were washed up on their shores. Many still remember being taken to the dark gloomy undercroft (now the site of the bookshop) to see them as children. (Taken by Alan Wiper)

Bishop Cosin's seventeenth-century almshouses on Palace Green, *c.* 1978. They were designed by John Langstaff and erected in 1666 to provide accommodation for poor members of the community. The turreted building to the right is the Pemberton lecture rooms (by W. D. Caroe in 1929). (Taken by J. K. Willis)

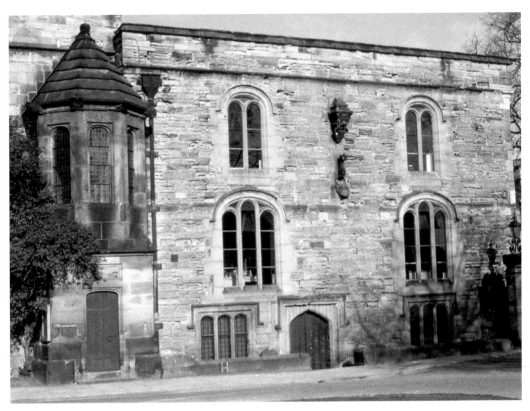

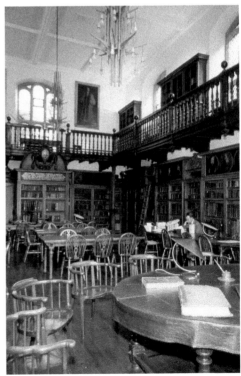

Above and right: Bishop Cosin's Library, Palace Green, *c.* 1966. This purpose-built library was founded in 1669 and was the first public lending library in the North East. Bishop Cosin gave £3,000 plus more than 5,000 books collected by him. Since 1832 it has been run by Durham University, as part of the university library. Beyond the pillar (to the right) is the entrance to the castle. (Both taken by Alan Wiper)

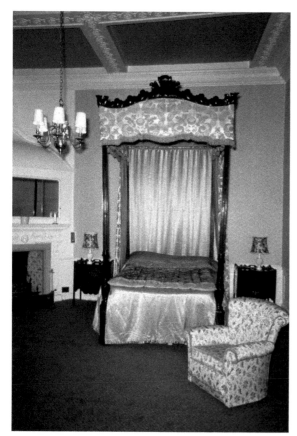

Left and below: The Bishop's Bedroom (above), Durham Castle, *c.* 1967. The bishop still retains the right to use his rooms. The Bishop's Drawing Room (below) (now the Senate Suite) in Durham Castle. The Flemish wall tapestries date from the seventeenth century and illustrate scenes from the life of Moses. (Both taken by Alan Wiper)

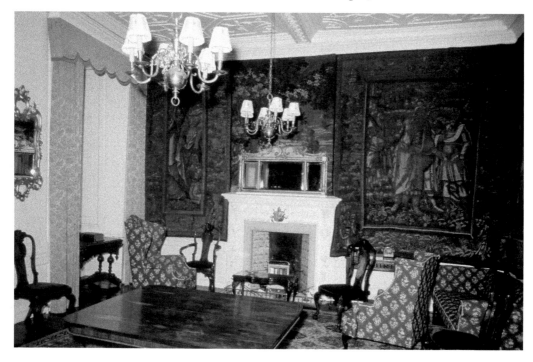

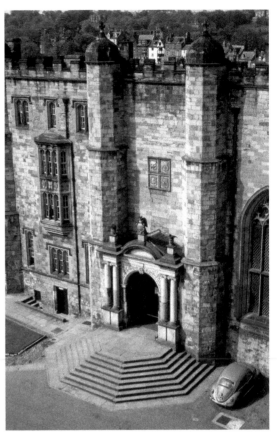

Right: The main entrance to the Great Hall, Durham Castle, *c.* 1966. The hall was built by Bishop Bek (1283–1311) and later modifications were carried out by Bishop Cosin (1660–72). The car is a VW Beetle. (Taken by Alan Wiper)

Below: The Assize Judge's Bedroom, Durham Castle, *c.* 1967. The room was part of the accommodation taken over by the Judges of Assize, during the thrice yearly visits. They ceased staying in the castle in 1971. (Taken by Alan Wiper)

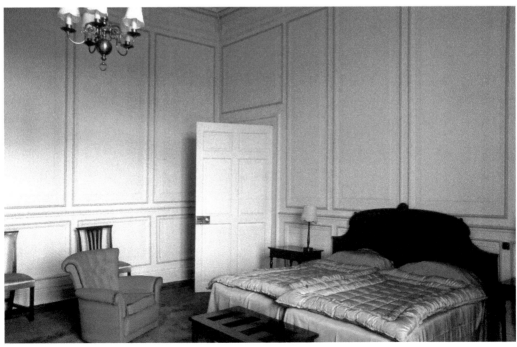

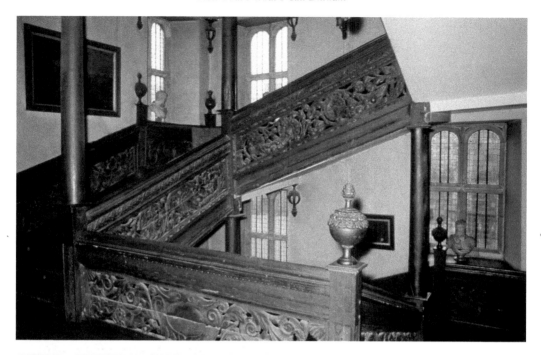

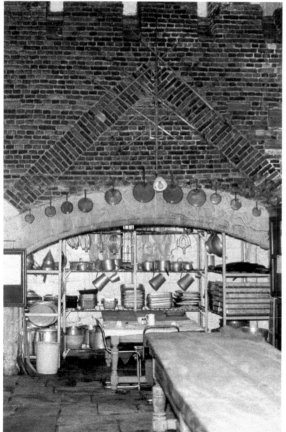

Above: The Black Staircase (actually brown), Durham Castle, *c.* 1967. It was constructed by Bishop John Cosin in the late seventeenth century and designed as a flying staircase with no vertical supports. The staircase started to lean soon after construction, so wooden posts were put in and are still in place. (Taken by Alan Wiper)

Left: The kitchen, Durham Castle, *c.* 1967. It dates from the end of the fifteenth century – the time of Bishop Fox. It has been in continuous use as a kitchen since 1499. The elaborate brick chimney breast is said to be the earliest use of brick in County Durham. (Taken by Alan Wiper)

The buttery, Durham Castle, *c.* 1967. The wooden hatches here have the date 1499 carved into them, and were made during the time of Bishop Fox (1494–1501). The term 'buttery', the area before the kitchen, comes from the French word 'boterie', a place where wine was stored. This became a common term for a larder, but has no connection with the working or storage of butter. (Taken by Alan Wiper)

Colin Wilbourn's carving of the Upper Room, on the riverbank of the peninsula, *c.* 1989. He had carved the trunks of thirteen diseased elms erected in 1988. It remained in situ until 2001, but by then the wood had deteriorated beyond repair. (Taken by John Bygate)

Wood and Watson's 'Pop' Factory, viewed from St Giles' churchyard, 1987. In the distance is Vane Tempest Hall (Gilesgate Community Centre). The lane between the factory always had a strong smell of malt vinegar, another product produced there. (Taken by John Bygate)

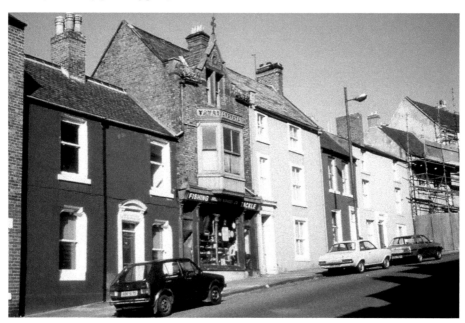

Anglers Services (previously Telfer's Fishing Tackle Shop), Claypath, late 1970s. A stopping-off point to buy a fishing licence, catapult elastic, air-rifle pellets and a pint of maggots for fishing in the Wear. Lonsdale Insurance Brokers is on the left. The cars are an Mk1 Volkswagen Golf, Vauxhall Viva HC and Mk1 Vauxhall Cavalier.

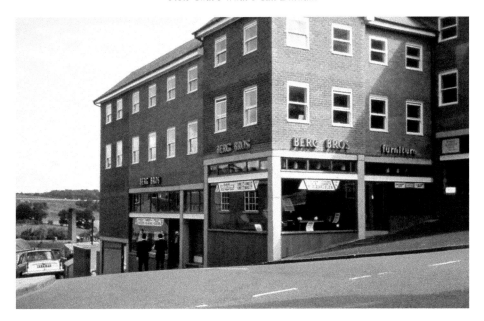

Berg Brothers Furniture Store (now student accommodation) at the top of
Providence Row, *c*. 1965. The left part of the building was also once, City Council
Offices, later renamed 'Ruth First House'. The chimney on the left belongs to the
laundry next to The Sands. The car on its way down is a Triumph Herald.

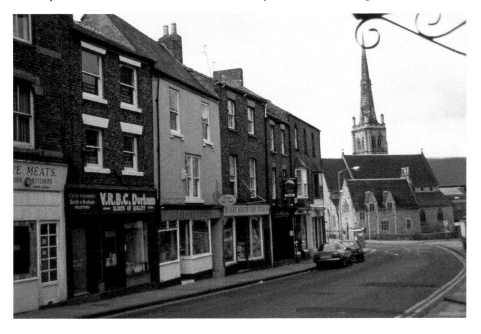

The lower end of Claypath in the 1980s, which then comprised a good selection
of retail premises. Those shown are Empire Meats, butchers; Smith & Graham,
solicitors; V. R. B. C. Durham, blinds of quality; E. J. Corby, pet shop; and Blacks,
a health shop. The two cars are a Ford Orion and an MK1 Honda Civic.

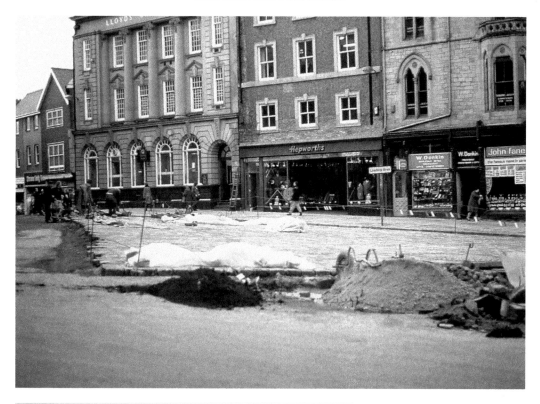

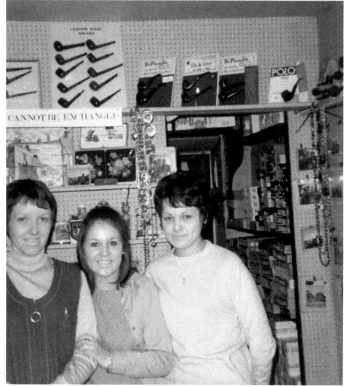

Above: The Market Place during resurfacing and pedestrianisation in 1975. The business premises (from left to right) are Lloyds Bank, Hepworth's Gent's Outfitters, Donkin's Tobacconists and John Fane Wine Merchant.

Left: The staff of Donkin's Tobacconists, 1970s. They are, left to right, Marjorie Botwright, Ethel Gleason and Susan Vest. They had a fantastic selection of pipes and later also stocked items of jewellery and other small gifts.

A view from the tower of St Nicholas's Church on Market Day, early 1970s, showing a white Commer van, two Bedfords and the truck is a Commer. Note the granite setts in the Market Place.

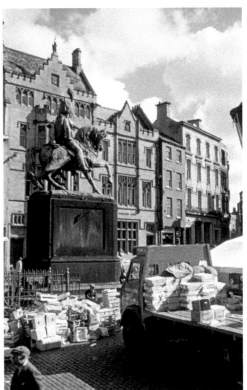

The Londonderry statue, market day. On the left of the photograph are the iron railings belonging to the gents' underground toilets, photographed in 1971.

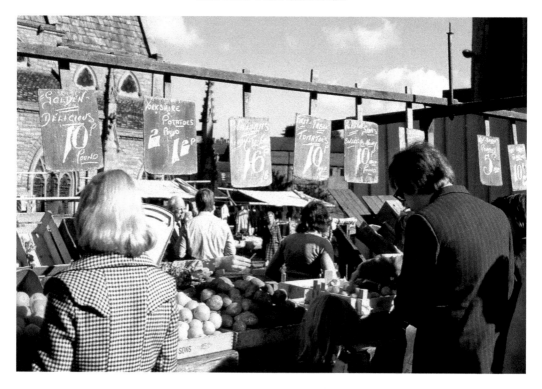

A fruit and vegetable stall in the Market Place on Market Day, 1975. Note the prices: golden delicious apples at 10p per pound, 2 lbs of Yorkshire potatoes for 12p and not a plastic carrier bag in sight.

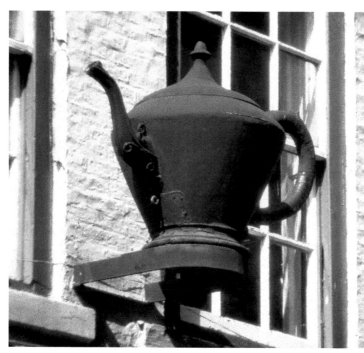

The famous Durham teapot, outside the House of Andrews Bookshop, *c.* 1979. It was restored by Durham City Trust in 2018. During this work it was revealed that it had once been gold. It has now been regilded as it was originally.

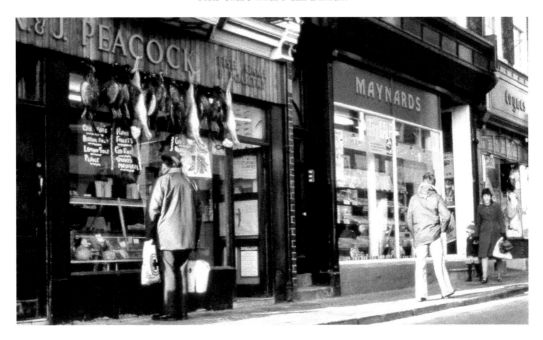

Saddler Street, showing the business premises of K. & J. Peacock, Fish, Game & Poultry Dealer, Maynard's sweet shop and the popular Coynes ladies' and children's outfitters in the 1980s.

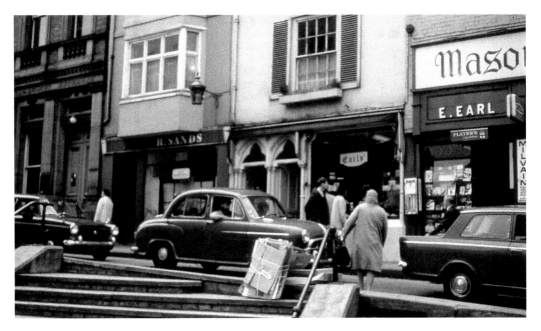

Magdalene Steps, Saddler Street, *c.* 1969. The business premises, from left to right, are H. Sands, hairdressers, Earl's famous bakers and the 'tiny tobacconists' also run by the Earl family. The cars are, from left to right, an Austin/Morris 1100, a Morris Oxford and a Vauxhall Viva.

Left: Elvet Bridge, 1971. From Left to right: Gray, Bros & Co., electrical engineers; Fillinghams Photographers; Levey's wallpaper; Boydells toy shop; and Pattisons upholstery.

Below: The Union Surgical Stores, Elvet Bridge, 1970s. Among the obvious items stocked it also sold home brew kits and herbal cigarettes. The shop on the left was the Silk Factory, selling threads, paper patterns and dress material.

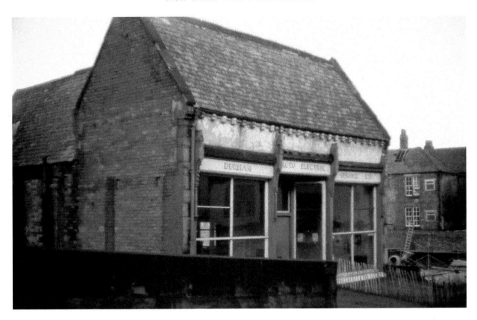

The vacant Durham Auto Electrical Services Ltd premises, Elvet Bridge, 1972, which is now the Swan & Three Cignets. The business closed here in 1971. They worked on starter motors and dynamo rewinds down in the basement. Mr Scott, a retired police inspector, looked after the shop and used to 'date stamp' the lead battery terminal for warranty proof.

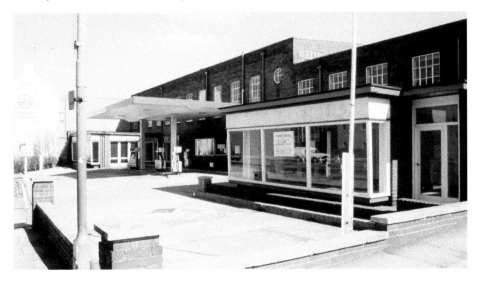

Fowler and Armstrong's Garage and (ICI) petrol station, New Elvet, 1987. The notice in the window says 'premises acquired for Luxury Retirement Flats'. They also had premises in Meadowfield. Leading off on the right is Court Lane. The old police station was behind and often when the police were short for ID parades, they would come down and ask staff from the garage to stand in the line-up. It is now the location of Orchard House apartments.

Left: Pattisons upholstery workshops, Back Lane (they also made coffins), *c.* 1988. It is now an annex of the Marriot Royal County Hotel. Pattisons were a family business and a household name for home furnishings. The car is a Datsun.

Below: Looking down busy Silver Street in 1974. Halfway down on the right is the hidden timber-framed medieval building (now with its timber exposed). Note the stationary Bedford CA van.

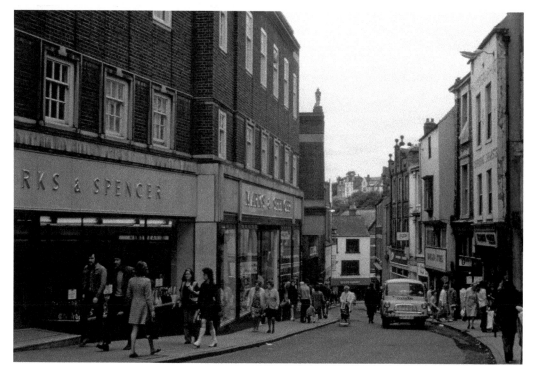

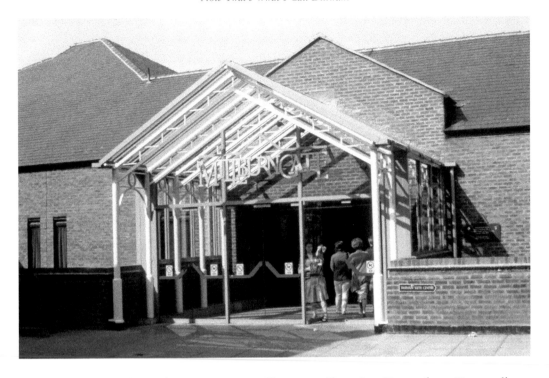

Above and below: The entrance to Milburngate Shopping Centre from Framwellgate Bridge, 1984. Then all undercover, handy during bad weather, it has now been redeveloped and opened up to the elements. Note the cleaner shining the glass doors. Below is the inside view of Milburngate Shopping Centre. Presto was a supermarket, which was later converted to a 'Safeway', followed by Waitrose and then Wilko.

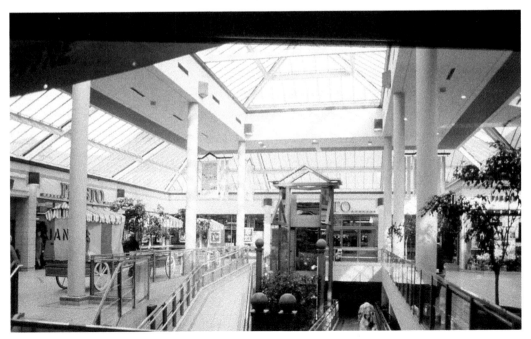

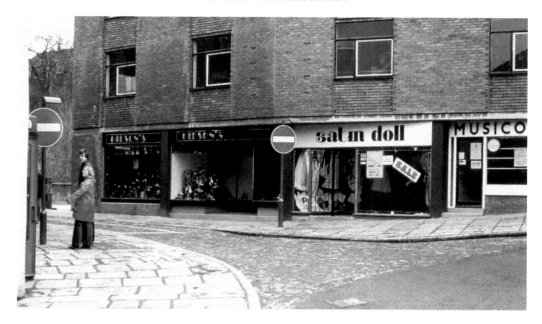

Business premises on the North Road side of Framwellgate Bridge, 1977, including Gibson's shoe shop; Satin Doll, young ladies' clothes; and (the closed) Musicore record shop situated in the ground-floor premises of Bridge House.

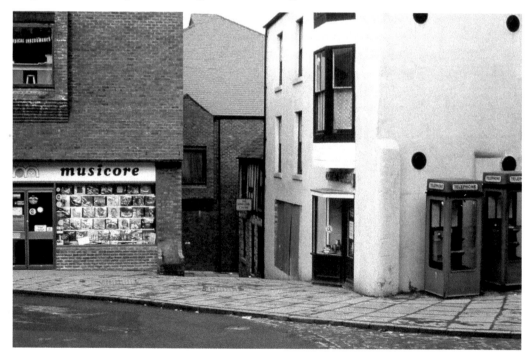

Musicore's new shop, part of the Milburngate Shopping Complex, 1977. To the right is the Corner Bakery (the shop at the bottom of the lane was the Jewellery Centre). The lane in the centre was originally much wider, as it was the main road to Milburngate.

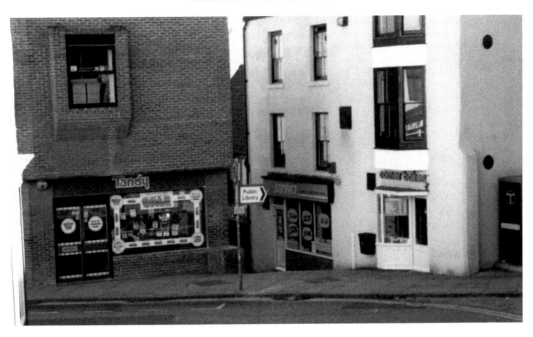

Tandy's Electronics and Radio store, 1980s. The premises in the centre was called Compact, a cheap make-up shop, and the property with the blue frontage was the Corner Bakery.

Ye Old Elm Tree public house, Crossgate, 1984. The rendering has since been removed to expose the original brickwork. To the left of the pub the owners have since converted the garage into a pancake restaurant.

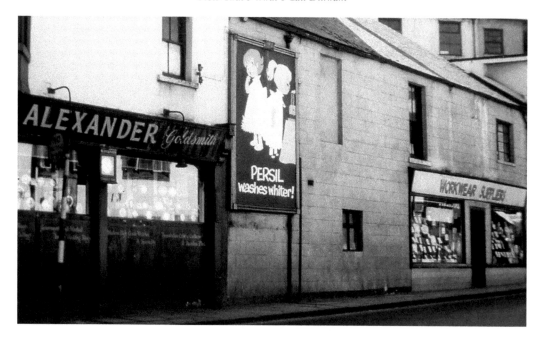

Alexander Jewellers and Workwear Suppliers, North Road, *c.* 1971. Workwear was a popular shop for their haversacks. Note the billboard advertising Persil washing powder. This area is now occupied by the Halifax Building Society, Specsavers and Greggs.

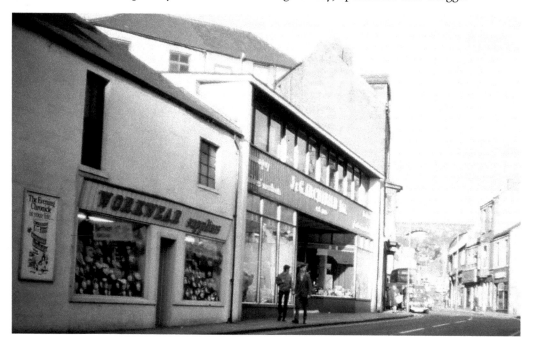

Workwear Supplies and Archibald's store, North Road, *c.* 1972. This section of buildings was demolished to make way for smaller retail premises. Many people used Archibald's store as a shortcut, bringing you out in Crossgate.

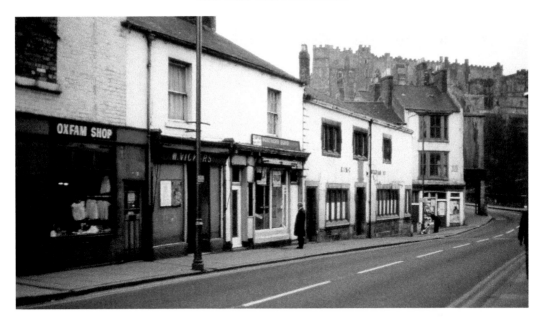

Bottom end of North Road, 1973. The photograph shows possibly Durham's first Oxfam shop, W Vickers (menswear), Lawson's (Chic & Annie) Newsagents and the King William IV public house.

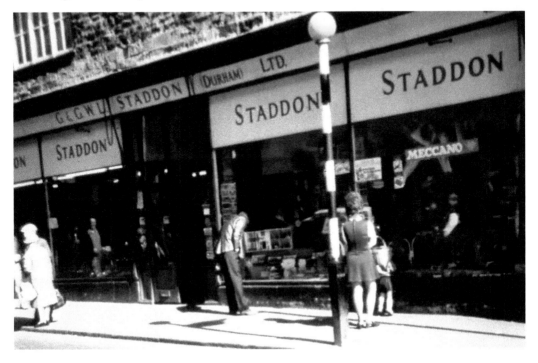

G. & G. W. L. Staddon (Durham) Ltd, toy shop, North Road, 1970s. This was a popular window for curious youngsters, especially those like myself, interested in 'Meccano'. They also sold prams. Many will remember the distinctive yellow-tinted sunscreens.

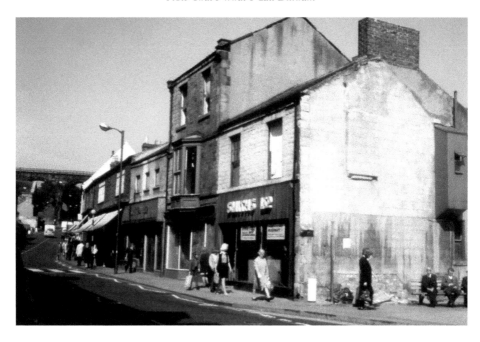

North Road, near Clarkes Corner, showing Smith's furniture shop on the right, 1972. The posters mention their move to temporary premises in Milburngate (*see* p. 33).

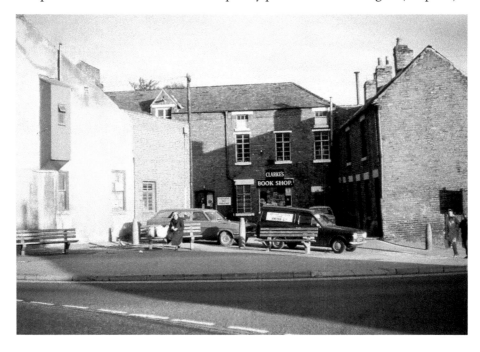

Clarkes Bookshop, Lindsley's Yard, North Road, *c.* 1972. The cars are a Vauxhall Victor estate, Ford Escort van and a Marina at the back. Note the curious wooden extension on the left, which appears to be a toilet due to the proximity of the overflow pipe and frosted glass window.

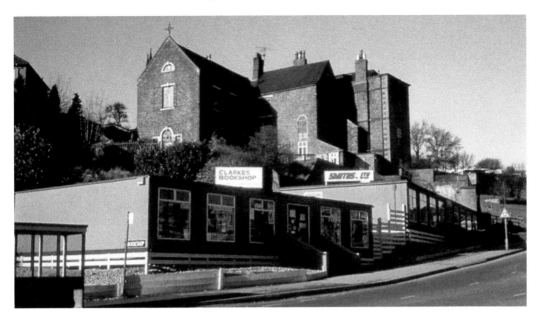

Clarkes temporary bookshop and Smiths Ltd (furniture shop) in Milburngate, 1974. The large building behind is part of St Godric's RC School. This had once been an eighteenth-century coaching inn called The Wheatsheaf.

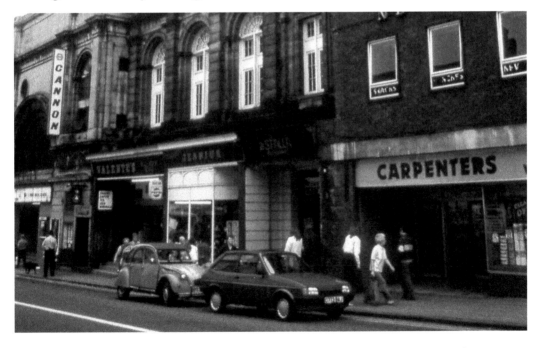

North Road showing the Essaldo picture house, Valentes coffee bar (with its pinball machine and milkshakes), Genius nightclub and Carpenter's wallpaper and paint shop (previously Moore's grocery shop), *c.* 1986. Above Carpenter's was the Neville Hotel. The cars are a Citroen 2cv and Mk2 Fiesta.

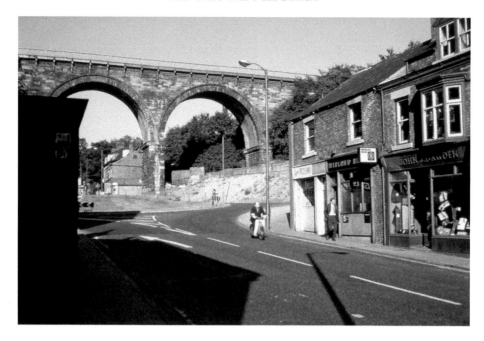

The top of North Road, *c.* 1973. Near the new roundabout, businesses premises on the right are The Globe prize bingo, Midland Bank and John Gauden gent's outfitters. Note the chap on the moped is not wearing a crash helmet.

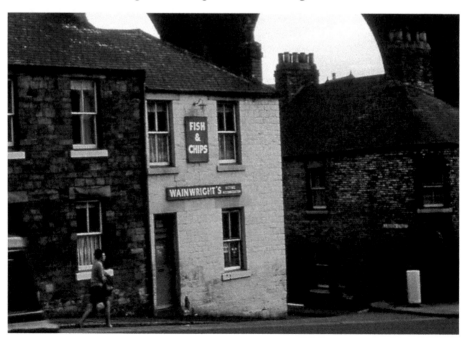

Wainwright's fish and chip shop (later, Marshall's and finally a Chinese takeaway) under the viaduct near Lambton Street, 1986. It was very popular with trainspotters visiting the station or nearby Wharton Park.

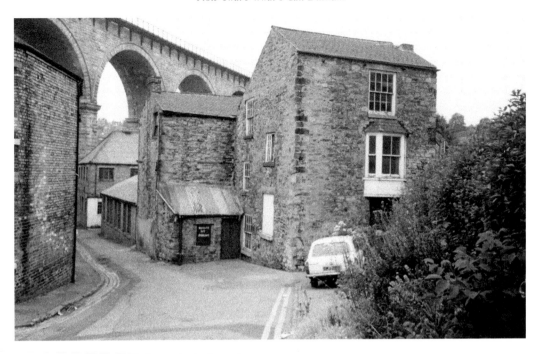

Above and below: Looking down the lane towards Luke's Bakery in 1989. The old stone building is called Bee's Cottage, which is believed to be the house of local diarist Jacob Bee (1636–1711). The bakery was located behind Sutton Street under the viaduct, now occupied by Housing Association apartments. This rear view of Sutton Street (below) shows the property's hidden basement, not seen from the front of the street.

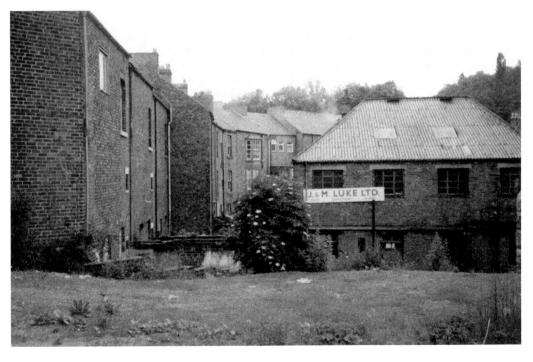

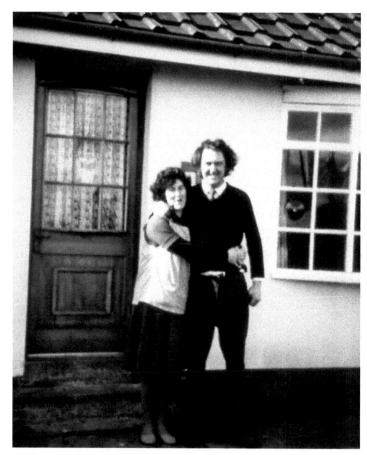

Left and below: George Robert Savage Nelson and his wife Irene, 1970s. George is the founder of the well-known family business of Nelson's Removals and storage. The image below shows an aerial view of the business premises of Nelson's on the Lanchester Road, 1980s. The site had originally been occupied by Tunstall House.

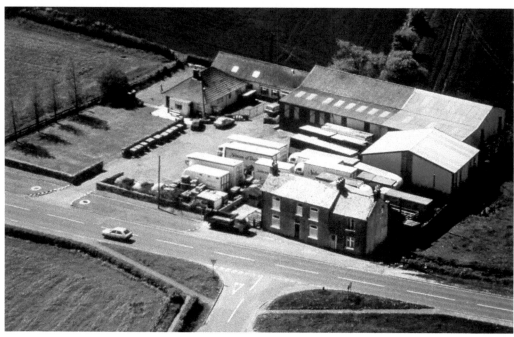

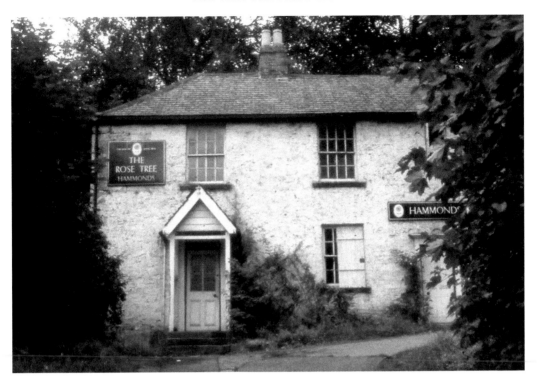

The Rose Tree public house, which was located at the end of Waddington Street near Flass Vale, 1972. It has been greatly altered and extended and is now renamed The King's Lodge.

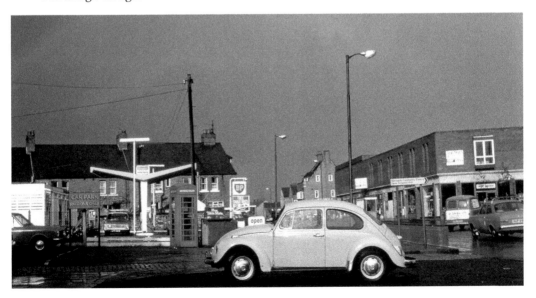

St Giles's Filling Station at the 'Road Ends', Gilesgate, *c.* 1973. This had originally been the site of St Giles' Church of England School and later became the parish hall. The car in the foreground is a VW Beetle.

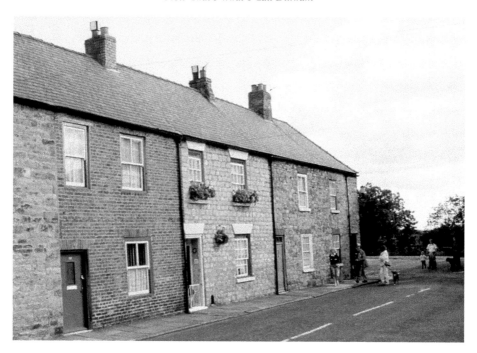

The Grade II-listed picturesque cottages (built around the 1840s), facing the 'Duck Pond' (Gilesgate Green), 1988. The left cottage is built using old English brick, the next one limestone and the last two sandstone. The two sandstone cottages were once one cottage. The ground floor was the workshop of Joseph Burnel, clay (tobacco) pipe-maker.

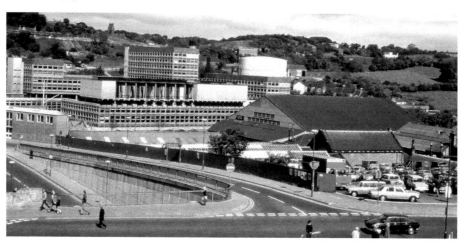

Milburngate House viewed from the rooftop of the multistorey car park, 1960s. To the right is the open-air car park now occupied by Millennium Place. Note the ice rink's large roof and below it the rooftops of the carpet factory weaving sheds. Milburngate House was built in 1965–69 to house the Savings Certificate Office of the Department for National Savings and the Ministry of Labour. It was formally opened by Princess Alexandra in March 1973.

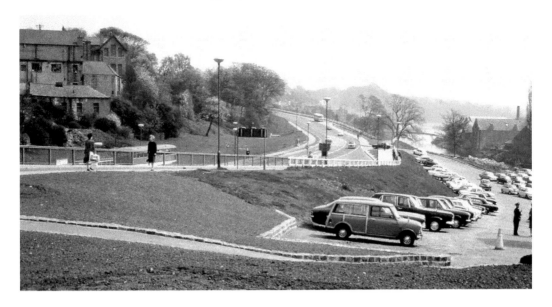

The large open-air car park which was located on the site of the present Prince Bishops Shopping Centre, 1960s. Note that Leazes Road has opened, but as yet there is no New Elvet Bridge or roundabout. To the left is Bailes the printers and the old Blue Coat School on Claypath is behind it.

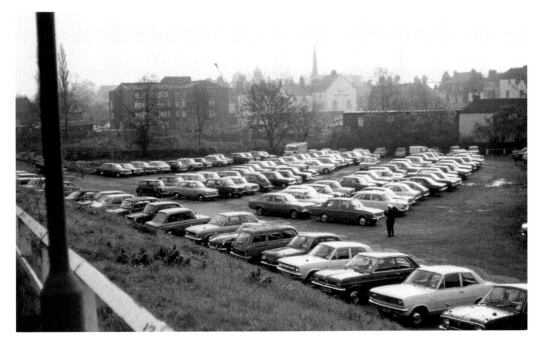

More of the same car park showing Brown's Boathouse to the right, 1972. To the left is the new extension belonging to the Royal County Hotel. A nice line-up of some now classic cars: Mk1 Cortina, Vauxhall Viva, Morris Marina, Mk1 Escort, Hillman Hunter, Austin Maxi, Hillman Imp, BMC Mini and many more no doubt.

The multistorey car park viewed from the Market Place, 1978. Many will remember the tight corners when moving to the different levels. Doggart's department store is on the right, and on the left, in the distance, is Bailes the printers. The car is an Austin 1800.

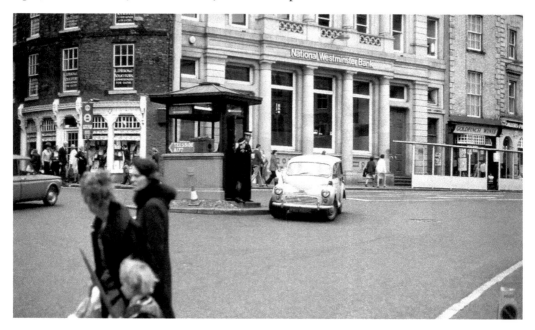

A car makes a tight manoeuvre around the police box in the Market Place under the watchful eye of two traffic wardens, 1970s. A policeman would have been in the 'box' directing traffic through the busy city centre with the help of cameras and TV monitors. Note the bus shelter on the right for buses travelling down Silver Street.

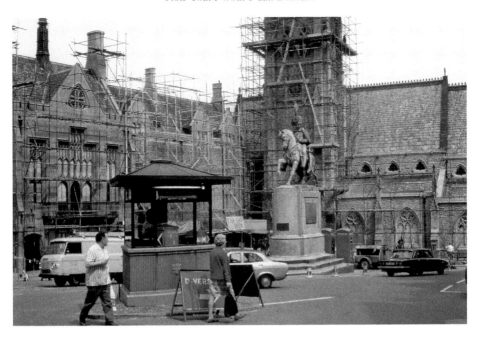

The Market Place during the sand-blasting of the New Market, the Guildhall, the Town Hall, the church and Lord Londonderry's plinth, 1973. In the centre of the photograph, a large hand-painted sign states 'Fish Shop Open'.

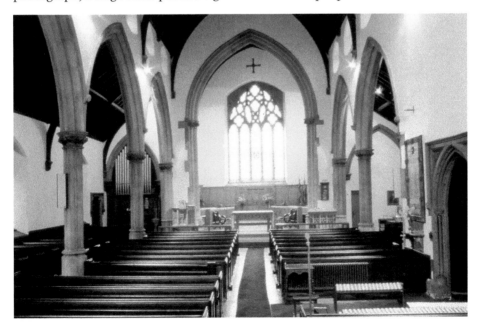

The Victorian interior of St Nicholas' Church prior to its restoration (1980–81) showing the pews, organ and open chancel arch, 1975. The church was reopened on 23 October 1981. The church is open seven days a week for various services and non-church events.

Looking towards Claypath from the Market Place. On the right is Doggart's department store, 1968. Note the colour of the stonework belonging to St Nicholas' Church (prior to its sand-blasting). The cars are a Vauxhall Viva, Hillman Imp, Morris 1000 and Triumph Herald.

The Market Place in the 1960s, showing Doggart's, Barclays Bank (with its 1929 extension on the right), *The Evening Chronicle* office and Martins Bank Ltd. Note the police box.

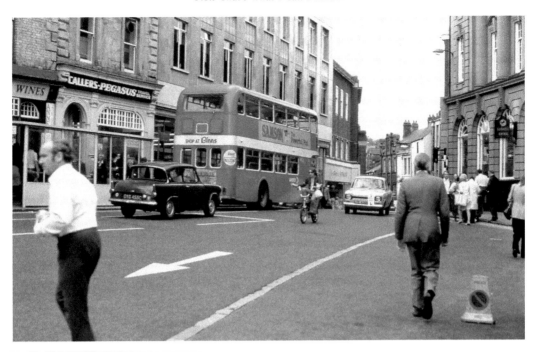

A busy Market Place showing traffic waiting to go down Silver Street, 1975. Note the young lad in the centre of the photograph riding his chopper bike. The vehicles are a Ford Anglia, Bristol Lodekka double-decker bus and a BSM Driving School Mk1 Ford Escort.

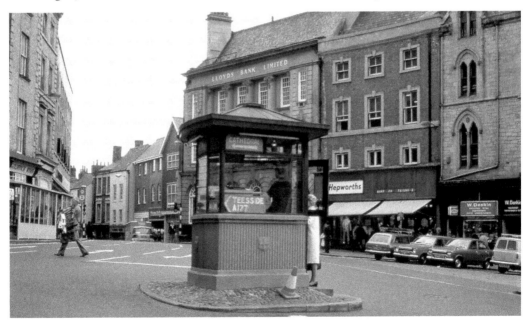

The police box, Market Place, 1975. On the right are Hepworths gent's tailors and Donkins tobacconists. The cars are, from left to right, a Ford Escort Estate, two Ford Escorts and a Bedford Viva van.

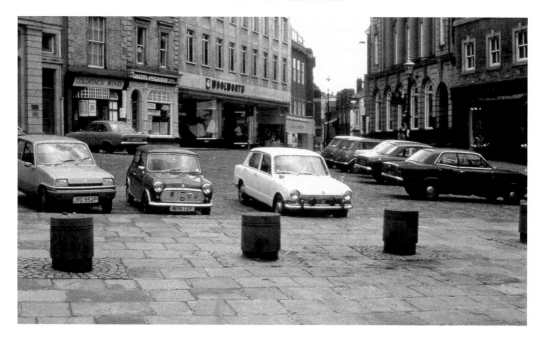

The Market Place with its 1978 layout showing car parking spaces. The cars are, from left to right, a Renault 5, MK1 Escort, Mini, Triumph 1300, two Minis, HC Viva, MK1 Escort and HB Viva. Note the Portland stone frontage of Woolworths.

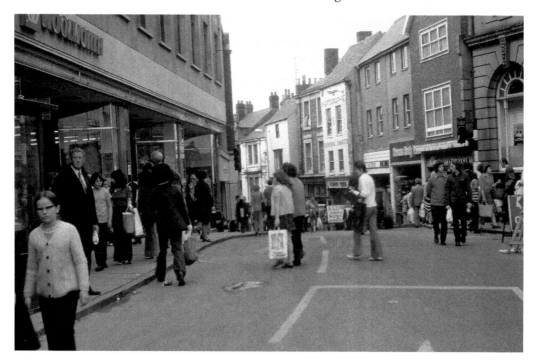

A busy street scene at the top of Silver Street near Woolworths, 1973. The street was open to traffic at the time. Note the sign for roadworks.

Two single-decker buses ease their way down Silver Street trying to avoid shoppers, 1970. Pedestrians appear oblivious to the dangers of the narrow footpaths.

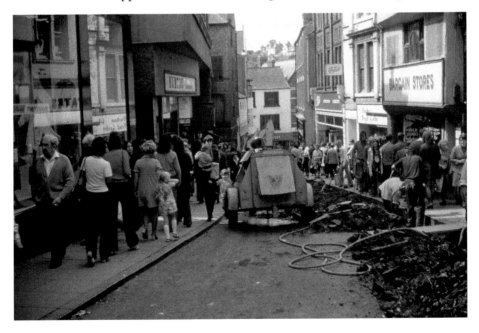

The new gas main being laid in a busy Silver Street, 1973 (in the days when we had a good selection of shops and the streets were always packed). Note there was not much in the way of health and safety regulations in those days.

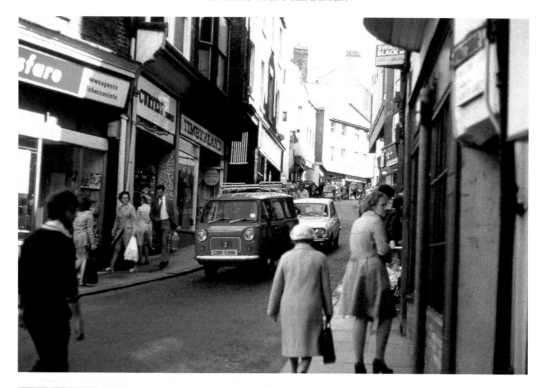

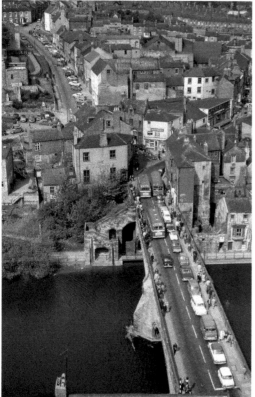

Above: Looking up Silver Street from near the entrance of Moat Side Lane, 1975. A Renault 850T van is followed by a Renault 12TL. On the left side of the road is Curtis's shoe shop, popular then for their platform shoes. Next door up from it is Timberland.

Left: Crossgate area from a window in the castle, *c*. 1966. The large building in the centre is the old Criterion public house. Note the small car park before St Margaret's Church near the top left. There is a long line of vehicles at the traffic lights waiting to climb Silver Street. (Taken by Alan Wiper)

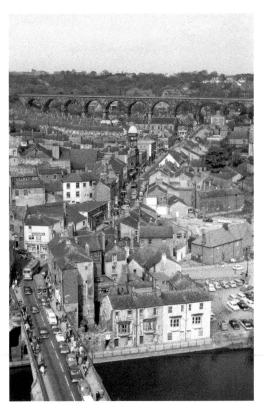

Right: A view from the castle window showing the North Road area, *c.* 1966. Note the domed top of the old Miners' Hall in the central area of the photograph advertising the Essoldo cinema. Ten of the eleven arches belonging to the railway viaduct are clearly visible. (Taken by Alan Wiper)

Below: Looking across the river towards the bottom of Silver Street from the old city library, South Street, showing New Day and Stylo shops, 1968. Many used the hidden side steps on the left of the building to reach the riverside footpath.

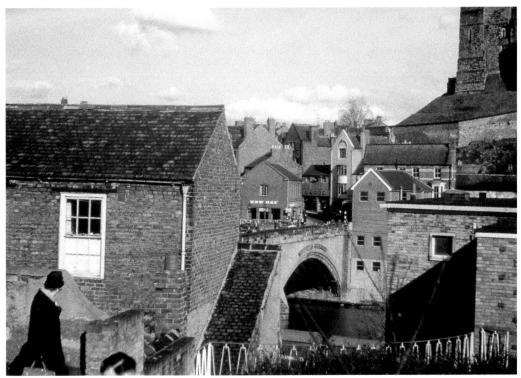

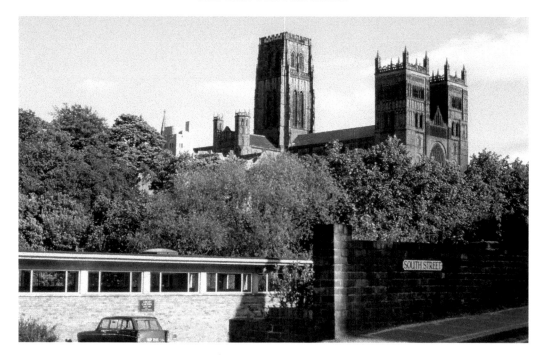

The cathedral viewed from the bottom of South Street next to the old city library (built by Bell & Ridley), 1970s. The car is a Morris Oxford Estate. Town houses and apartments occupy the site today.

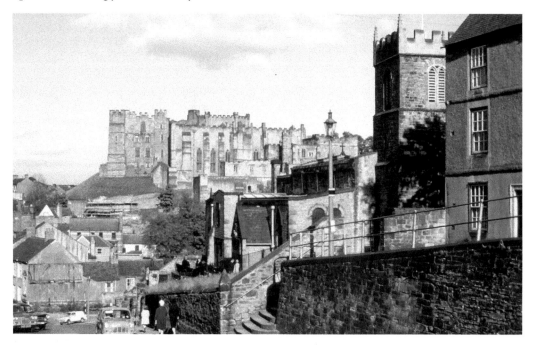

The castle viewed from halfway up Crossgate, 1970s. On the right is St Margaret's Church. The mound of the castle keep was then well attended to.

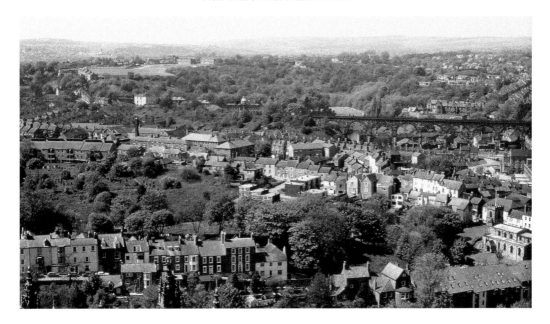

South Street and Crossgate area viewed from the cathedral tower, 1960s. To the left of the skyline is the new Johnston School, Crossgate Moor. Note the railway viaduct stretching across the right-hand side of the photo and St Margaret's Church to the bottom right.

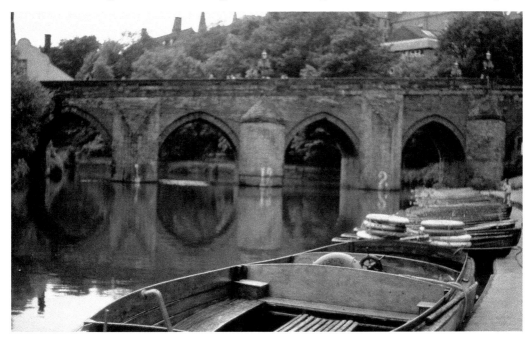

The Dunelm pleasure boat, minus its canopy, at the landing stage of Brown's Boathouse next to Elvet Bridge, 1967. The boat was later restored by pupils from St Leonard's RC School. It still survives in the Lake District, after spending some time giving pleasure trips at Newby Hall, North Yorkshire.

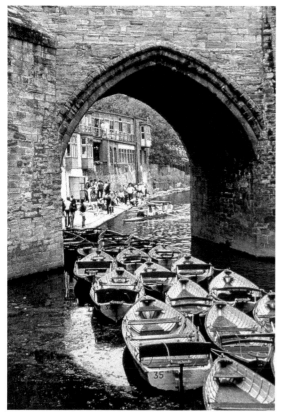

Left: The distinctive burgundy and cream colours of Brown's hire boats, tied up under Elvet Bridge, 1970s. Several years ago this part of the river (near the landing stage) was dredged and hundreds of coins were found among the sludge, mainly dating back to the 1940s.

Below: Brown's Boathouse from the opposite side of the river, 1960s. The two cars in the foreground are a Hillman Super Imp and Morris 1100. The boathouse is now a bar and eatery called The Boat Club.

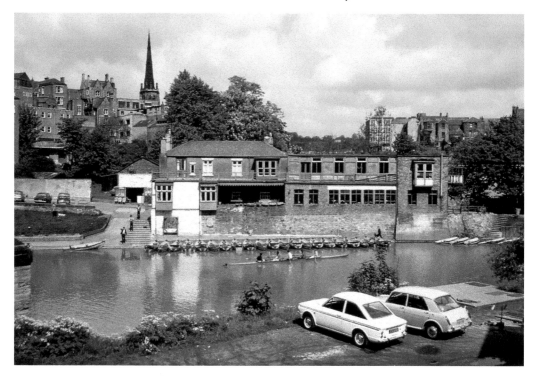

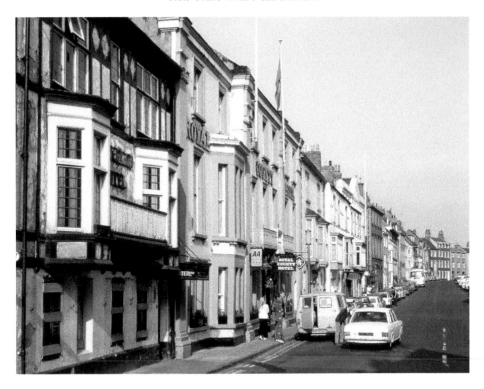

Looking along Old Elvet, 1971. On the left is the boarded-up Waterloo Hotel, which was demolished to make way for the new Elvet road bridge, and to its right is the Royal County Hotel.

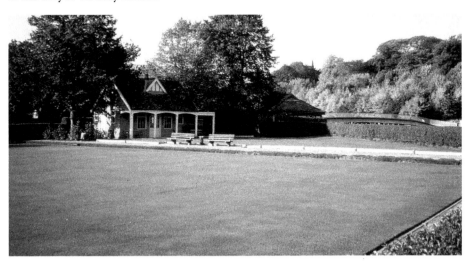

Durham City Council-run bowling green situated on The Racecourse, 1984. The attractive pavilion is now demolished and the bowling green has long since overgrown. This area is awaiting redevelopment, hopefully to be reinstated as a public recreation area of some description. Note the new Baths Bridge on the right, which was built in 1962.

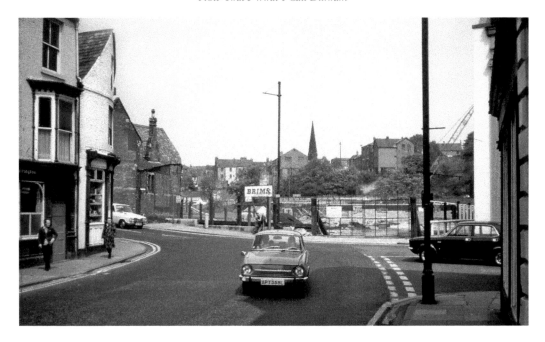

A Skoda Estelle turns the corner after leaving Elvet bridge at the junction of Old and New Elvet, 1973. The waste ground behind is where the former County Court building and the Waterloo Hotel once stood, which was demolished for the new Elvet road bridge. The other two cars, from left to right, look like a Renault 16 and a Marina.

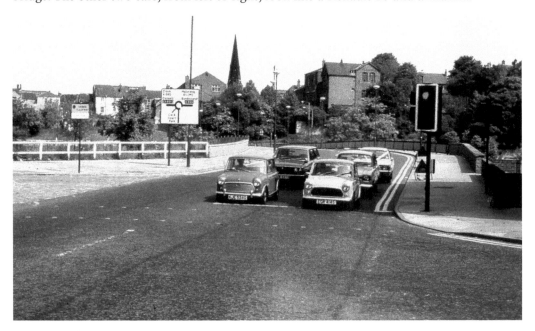

The new Elvet road bridge showing period cars of the 1970s. One of the cars has wedding ribbons tied on. The large brick building in the distance is the old Blue Coat School in Claypath (now the site of town houses, Blue Coat Court).

Right: A view from the cathedral tower, 1960s. In the bottom right corner is Museum Square, situated behind the Alms Houses on Palace Green (the square no longer exists, having been redeveloped for student accommodation). The tree-covered area at the top of the photograph is the former Paradise Gardens, then partly occupied by the girls' high school playing field. This is now the site of the new Leazes Road. (Taken by Alan Wiper)

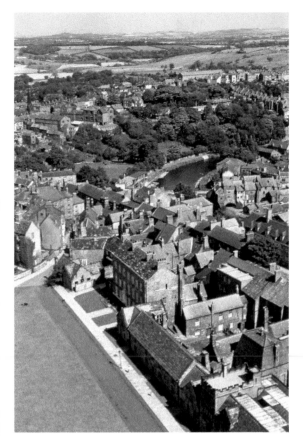

Below: Elvet area from the cathedral tower, *c.* 1966, showing New Elvet in the foreground and Pelaw Wood at the top, with Gilesgate/Sherburn Road estate on the skyline. (Taken by Alan Wiper)

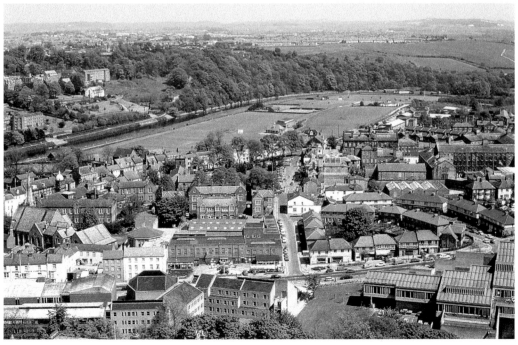

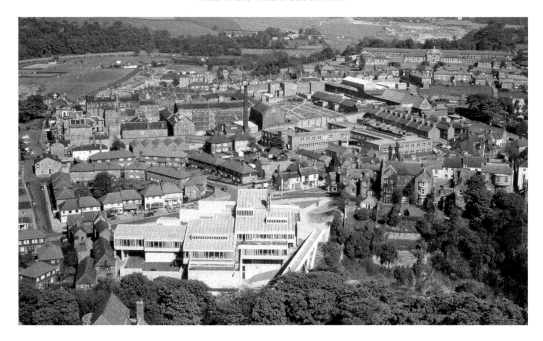

A shot from the cathedral tower overlooking Dunelm House with Durham Prison beyond it, *c.* 1966. The top right-hand corner of the photograph shows Whinney Hill School, and above it is the Old Durham Sand and Gravel Quarry. (Taken by Alan Wiper)

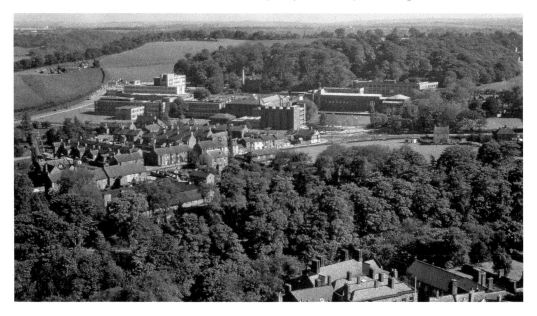

A photograph taken from the cathedral tower looking over the top of Church Street, towards the Science Site, *c.* 1966. In the top left of the photograph is Mount Joy Farm. Unfortunately, the university has now built upon much of the greenfield areas around this location. Dead centre is the New Inn, which is dwarfed by the castle-like University Library behind it. (Taken by Alan Wiper)

The old Whinney Hill School (opened 1932), 1986. Now demolished, the site is currently being occupied by expensive houses and apartments. The cars are a Nova, Montego and Cavalier.

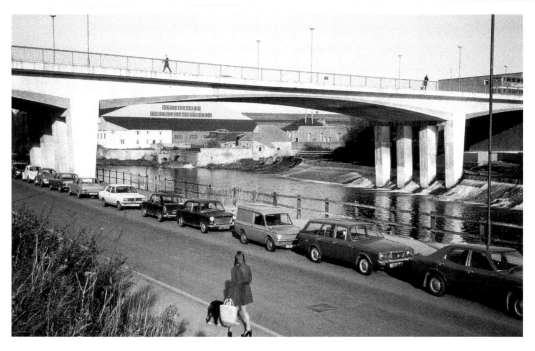

The new Milburngate Bridge viewed from Framwellgate Waterside, 1974. Under the arch of the bridge is the old Bishop's Mill. It housed a water turbine creating electricity to power the ice rink situated behind it. The cars are, from left to right, two VW Beetles, an Mk2 Cortina, a Morris Ital, Vauxhall Viva, Morris 1300, an Austin, a Hillman Imp van, Hunter Estate and Cortina.

A view across the river from Milburngate, showing the back of the Indoor Market and Town Hall, 1974. Note the hoist for lifting livestock up to the market hall, which when built was occupied mainly by butchers.

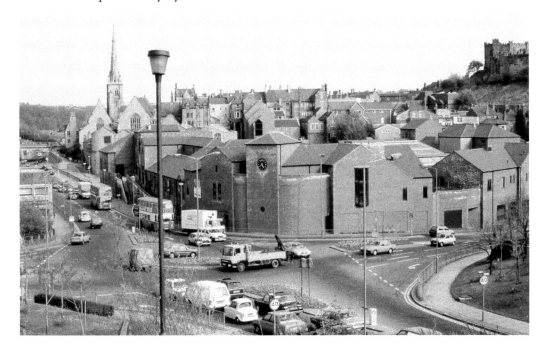

A view of the busy Milburngate Roundabout with the bland outer walls of Milburngate Shopping Centre, 1987. They got it right then with the roofline, unlike the present building, which is far too high.

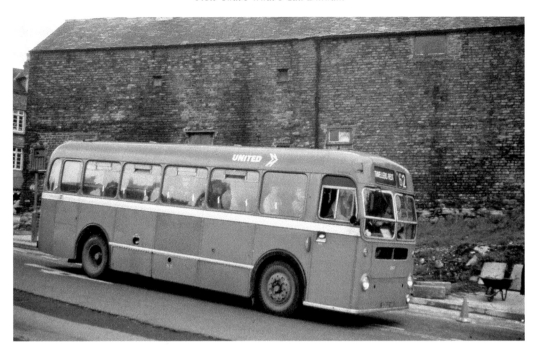

Above and below: A United bus, the No. 62, Travellers' Rest, photographed in Milburngate after leaving North Road. The building is the rear of Lindsley's Yard, which was situated just off North Road at Clarke's Corner. It is now the site of The William Hedley pub. Note the old brick building has a stone foundation and not many windows in the rear of the property. The two cars are a Volvo 144 and a Mini. Both photographs were taken in 1973.

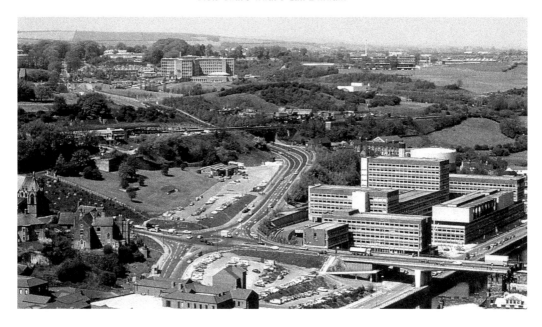

Photographed from the cathedral tower overlooking the Milburngate and Framwellgate area prior to the second phase of the Milburngate Shopping Centre, *c.* 1966. In the distance, to the left, is County Hall. The large building centre, beside a car park, is Globe and Simpson's/Lucas auto electrical garage. (Taken by Alan Wiper)

The 'secret park' with its steel boat at the back of Laburnum Avenue, near the former Harrison's organ factory, 1989. The old brick building on the left was built as a Jewish synagogue.

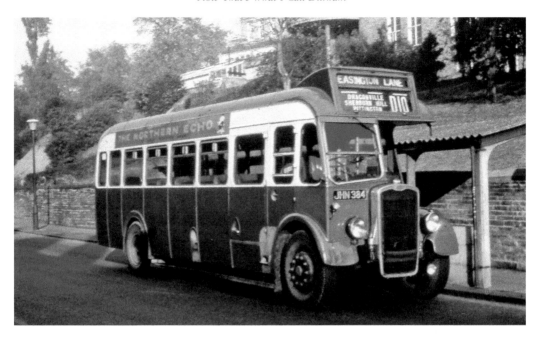

The green Durham District bus at the bottom of Sutton Street below Durham County Hospital, 1960s. The D10, Easington Lane, stopped at Dragonville, Sherburn Hill and Pittington.

The parcel entrance to Durham railway station, 1975, which was originally built as the main passenger entrance (to which it has now reverted). The period cars, from left to right, are a Hillman Hunter, a Ford Capri and a Mini Traveller.

The newly built Durham County Hall from North End, early 1960s. Completed in 1963, it was officially opened by the Duke of Edinburgh on 14 October 1963 (*see* p. 83). It is now due to be demolished in the near future.

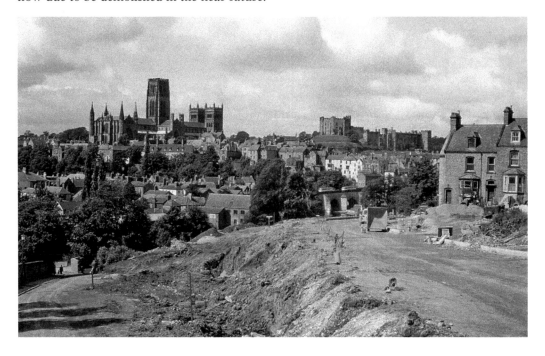

The cathedral and castle viewed from the construction site of what was to become the new Leazes Road, 1960s. On the right is Ravensworth Terrace. Two lots of properties were demolished to make way for the new roads: Pelaw Terrace and Pelaw Leazes.

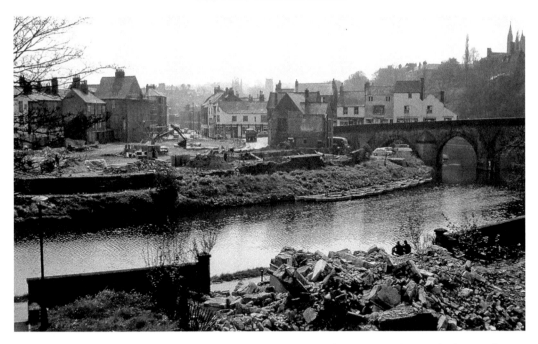

The demolition of Miss Gleghorn's Cottage (Henderson's Lodge), which stood near Brown's Boathouse, *c.* 1971. This was to make way for the new Elvet road bridge.

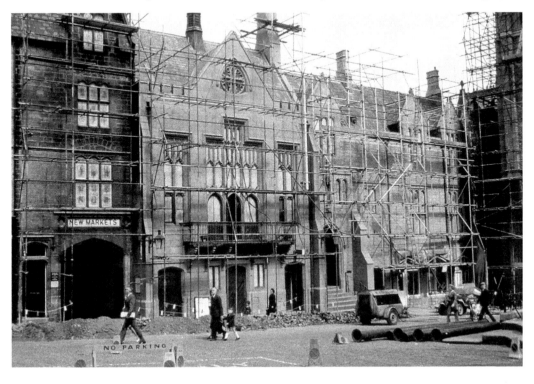

The scaffolding-covered New Market's, Guild Hall, Town Hall and church during the sand-blasting of the stonework, *c.* 1973. After years of pollution the stone had become dark.

Groundworks in the Market Place, 1980s – the scene often repeated over the last thirty years. It is quite common for workmen to come across bones in this area from the old St Nicholas' Churchyard, which once occupied this part of the Market Place.

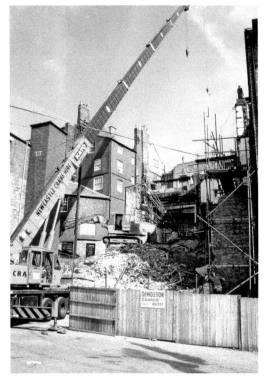

The demolition of the former Queen's Head, Silver Street, 1987. The property stood opposite the old Burton's shop. Photographed from Fowlers Yard, behind the excavator is the lane leading from Silver Street to Fowlers Yard. The tall brick tower-like structure is the lift shaft belonging to the former General Post Office.

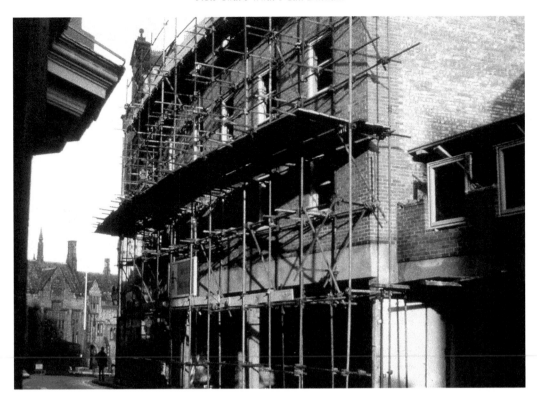

Above: The erection of the unsightly business premises in Saddler Street, 1973. It was once occupied by a bookmaker, the Co-op Bank and the Wimpy Bar Café and has now thankfully been demolished. It is now the Saddler Street entrance to the Prince Bishop Shopping Centre.

Right: The demolition of No. 69 Saddler Street, 1989. The photograph shows the intricate scaffolding supporting the two side walls (previously Dixon's electrical shop, now occupied by Waterstones bookshop). The van is a Leyland Sherpa. Note part of the castle turrets can be seen behind.

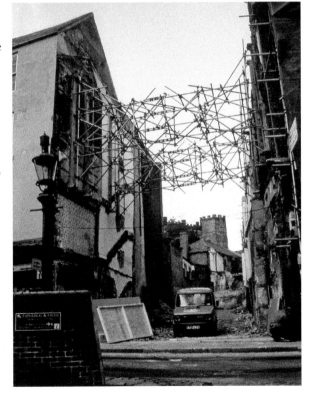

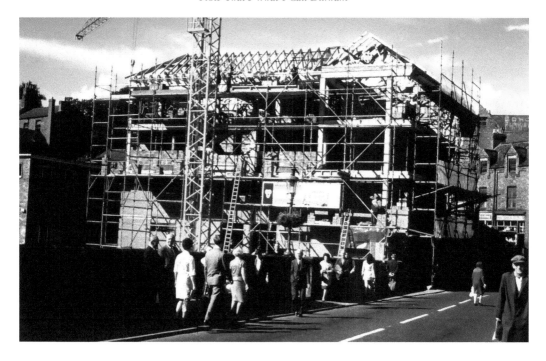

The building of Bridge House and the Coach & Eight pub on the North Road side of Framwellgate Bridge, 1968, which is not the most pleasing of buildings. On the left is the former city library in South Street.

Milburngate looking towards the bottom of North Road, 1973, shortly after the King William IV was demolished. It was opposite the shop In Time (now the site of the Halifax Building Society). A gable-end building on the left had been Stanton's fish and chip shop.

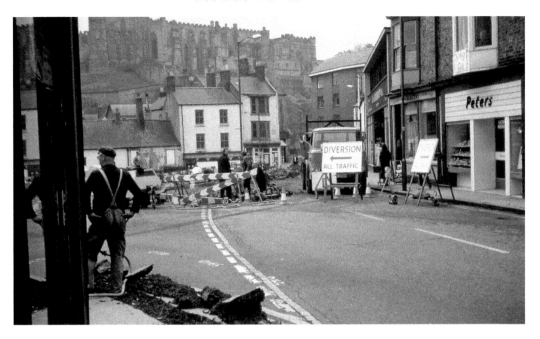

The bottom of North Road showing the modern turn-off down to Milburngate, 1973. Note Peter's bakery on the right and Robinson's pet shop to its left.

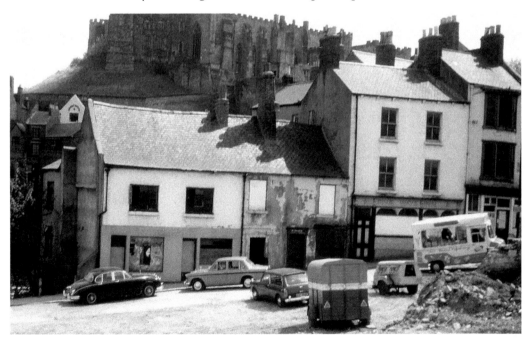

Looking across Milburngate, 1973. The view shows the old business premises, from left to right: Stanton's fish and chip shop, Maggie Reece's sweet shop, The Five Ways Inn public house and Oliver's wet fish shop. The vehicles are, from left to right, a Jaguar MK2, a Singer Gazelle, an Austin 1100 estate, an Atlas Copco Compressor and a Bedford C F ice-cream van.

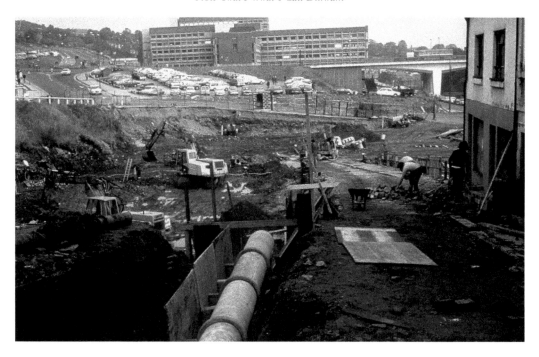

The ground being prepared for the first phase of the building of Milburngate Shopping Centre, early 1970s. The former Stanton's fish and chip shop is on the right.

Old business premises at the top of Milburngate behind the old King William IV, early 1970s. This view is from the car park in Milburngate. Behind the railings was the original road of Milburngate.

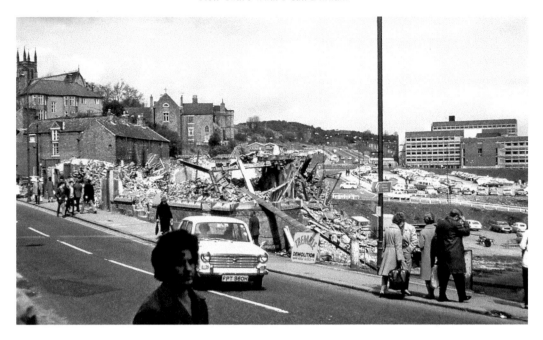

The demolition of the King William IV public house, North Road, and adjoining business premises, 1973. Note the name of the demolition company on the bright yellow sign – Tremble.

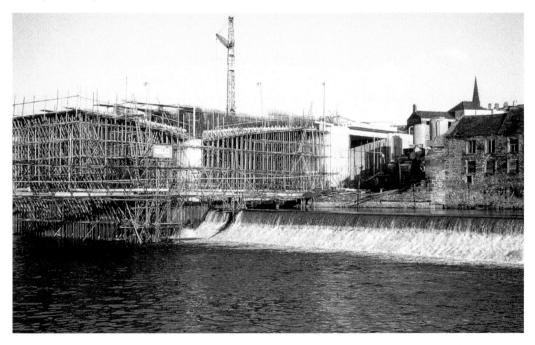

The mass of scaffolding needed while building the Milburngate Bridge, mid-1960s. The name of the company carrying out the work was Holst. The spire on the right belongs to the United Reformed Church in Claypath.

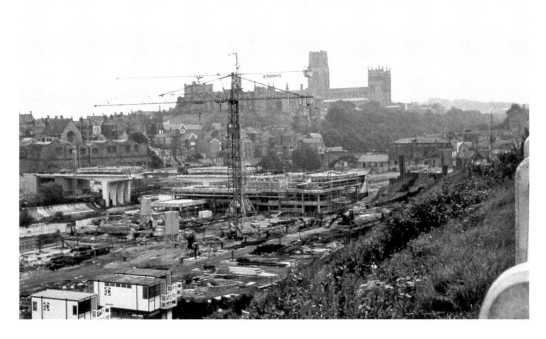

The building of Milburngate House and Milburngate Bridge viewed from Framwellgate Peth, 1960s. This area has now been cleared and is due to be redeveloped.

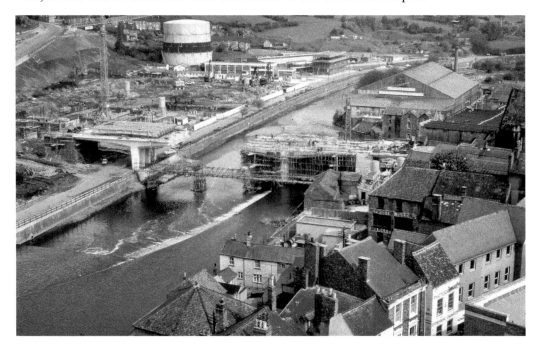

A view from the castle, looking over Silver Street and Fowlers Yard towards Framwellgate Waterside, 1960s. Note the gasholder belonging to Sidegate Gasworks. (Taken by Alan Wiper)

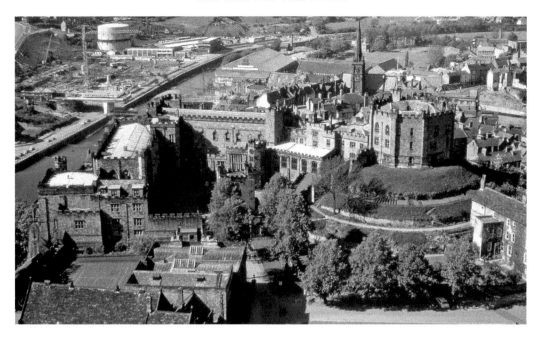

The castle from the cathedral tower, 1960s. Behind the castle keep (now student rooms for University College), St Nicholas' Church dominates the Market Place with its tall tower and spire. Note on the left is the marked-out lawn tennis court in the Fellows Garden. (Taken by Alan Wiper)

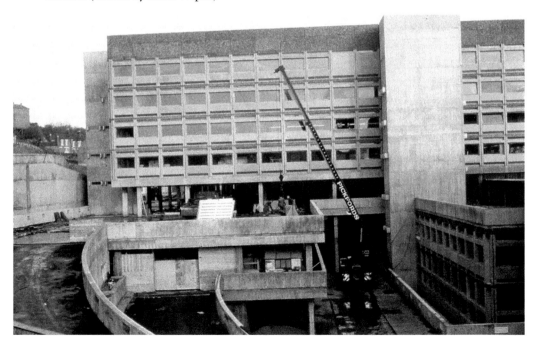

Pickford's removal company using a crane to lift heavy items into the new Milburngate House, 1968. To the far left is the rear of Durham North signal cabin.

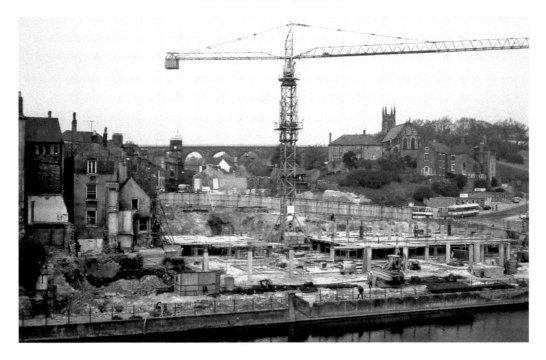

The building of Milburngate Shopping Centre, viewed from a window in Silver Street, 1970s. The rear of the former Fiveways Inn is shown on the left and to the right of the photo is St Godric's School, the older part of which was an old coaching inn named The Wheatsheaf.

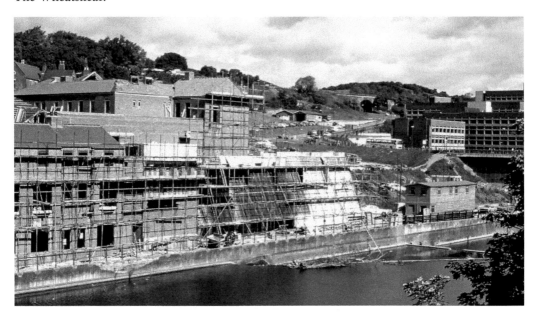

The first phase of the Milburngate Shopping Centre nearing completion, viewed from the bottom of Silver Street, 1970s. In the centre of the photo, in the distance, is the former Lucas garage, which was popular for car parts.

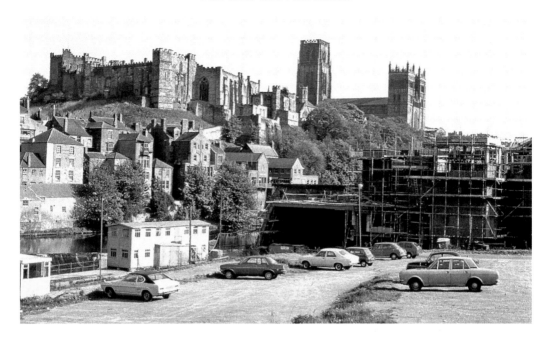

The cathedral and castle from Milburngate showing period cars in the open-air car park, 1975. Some very popular cars of the period are parked up: a Ford Capri MK1, Ford Cortina MK2, Vauxhall Viva HC, Hillman Avenger, BMC Mini, BMC 1100/1300, Reliant Robin and a Morris Minor 1000.

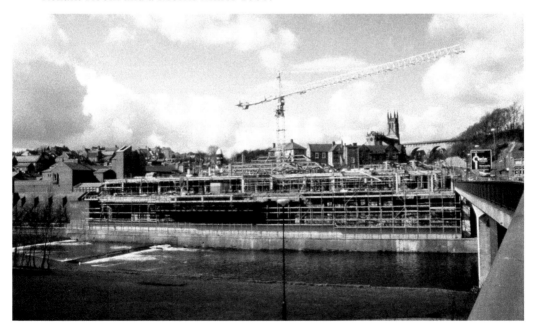

The building of the second phase of the Milburngate Shopping Centre viewed from Milburngate Bridge, 1986. The pleasant green open space in the foreground is now unfortunately occupied by student apartments.

Above and below: The demolition of the last remnants of the bottom of Atherton Street, 1988. The new building was the office of Age Concern; Metcalf House was built on the site of the demolished property. The old shop had been last occupied by Jeff Metcalf, a fruit and vegetable dealer.

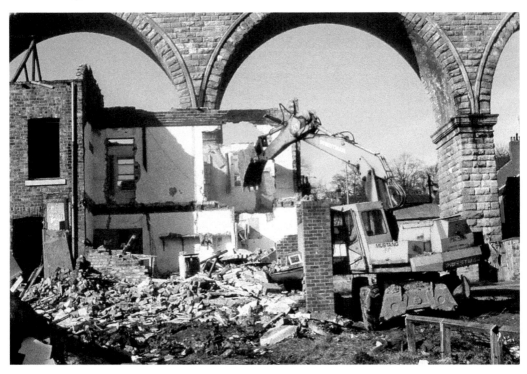

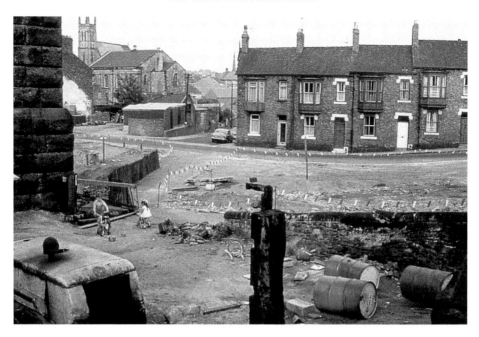

The bottom of Sutton Street shortly after the demolition of private houses and business premises, 1970. Note the children playing among the rubble, long before tighter health and safety regulations were introduced. On the far left is the tower of St Godric's RC Church and, nearer to the camera, the back of North Road Methodist Church.

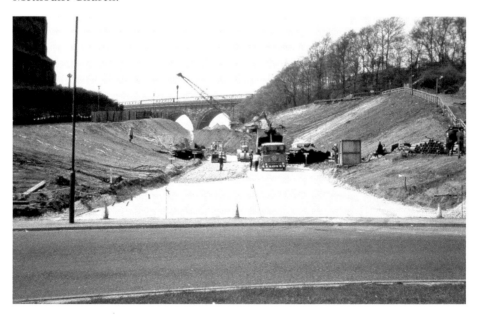

The construction of the new road linking Milburngate to North Road, 1971. The raised ground on the left was once the site of the row of houses named Co-operative Terrace.

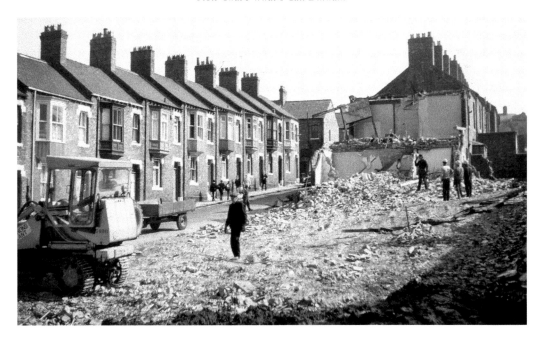

The lower end of Atherton Street during the demolition for the new stretch of road leading from North Road Roundabout towards Crossgate Peth, early 1970s. Sadly almost all of these town houses are now let to students, making this part of the city like a ghost town when students are away.

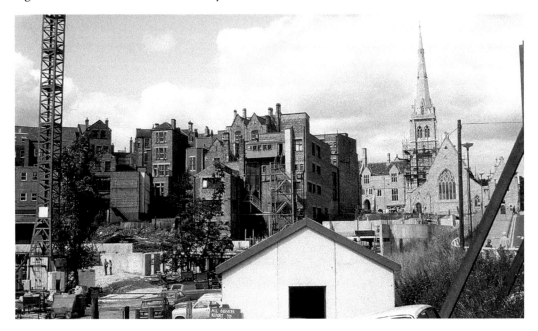

The rear of business premises in the Market Place and Saddler Street photographed during the construction of the multistorey car park, 1973. Note the iron fire escape to the rear of Doggart's department store.

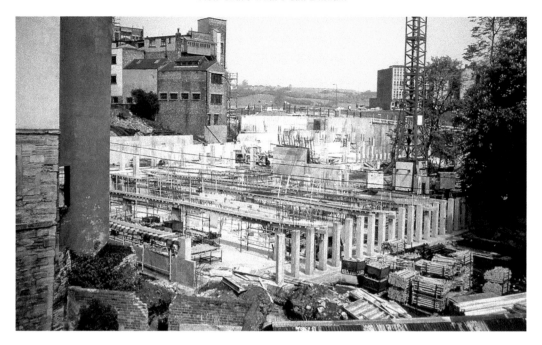

A view from Elvet Bridge during the construction of the multistorey car park, 1973. Paradise Lane once occupied part of this area and ran from Claypath to the back of Brown's Boathouse.

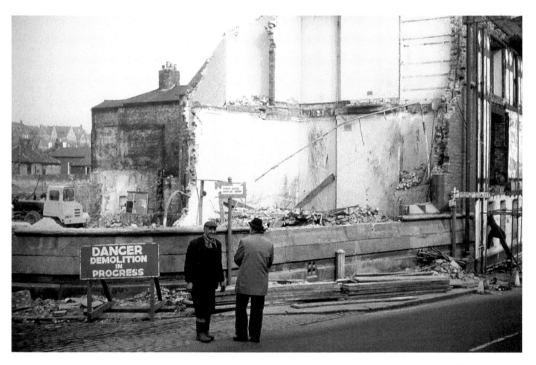

The demolition of the old Assize Court building and also its neighbour, The Waterloo Hotel, to make way for the access road for the new Elvet Bridge, 1971.

A view from Old Elvet looking towards Elvet Bridge, showing traffic heading towards the Market Place, 1971. Note the curved corner building, which was then Greetings newsagent. This had previously been the Prince George Hotel.

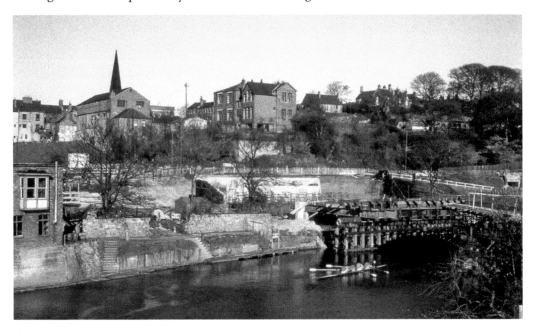

Looking across the river near Elvet Bridge during the construction of the new bridge, *c.* 1973. The four main buildings on the skyline, from left to right, were then Bailes the printers, Blue Coat School, Mr Middleton's bungalow and St Nicholas' Vicarage.

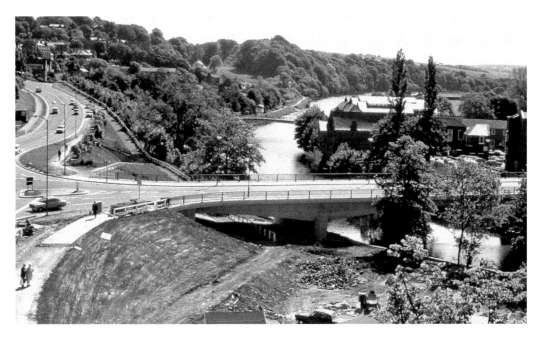

A view from the back of Doggart's department store showing the new Elvet road bridge, 1975. In the distance is the dense area of Pelaw Woods. The grounds of Hild/Bede colleges occupy the far left of the photo. It must have been near to Regatta Day as the official's box is in position on the Baths Bridge. It is no longer positioned on the bridge due to health and safety regulations.

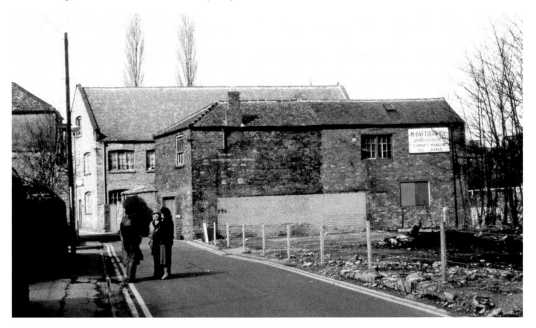

Pattison's upholsterers and cabinetmaker's workshops, Elvet Waterside, 1987. The derelict land on the right had previously been occupied by McIntyre's, a motor engineer's garage.

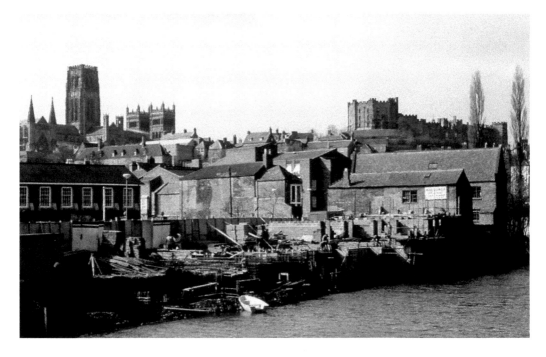

The building of Elvet Waterside town houses on the site of the former McIntyre's garage, viewed from Baths Bridge, 1988. The building on the left with veranda windows is the rear of the Territorial Army Headquarters in Old Elvet.

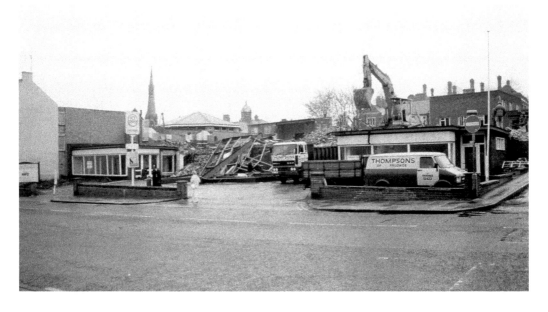

The demolition of Fowler and Armstrong's Garage and showrooms, 1988. The site is now occupied by Orchard House apartments. The spire belongs to Elvet Methodist Church and the domed top belongs to the former Old Shire Hall (now Hotel Indigo), both in Old Elvet.

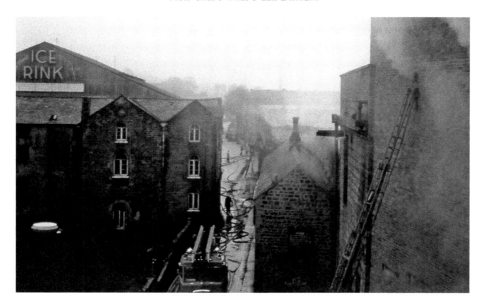

McKay's carpet factory fire, Freemans Place, 5 May 1969. The property on the right, 'Wilton House', and was then occupied by Jack & Marjorie Cowan. The fire was deliberately started by an employee and destroyed the Wilton department with the loss of No. 2 and partial loss of No. 1 sheds. The large stone building on the left was once known as Martin's flower mill. Note the neon sign belonging to the ice rink, now the site of Durham Passport Office.

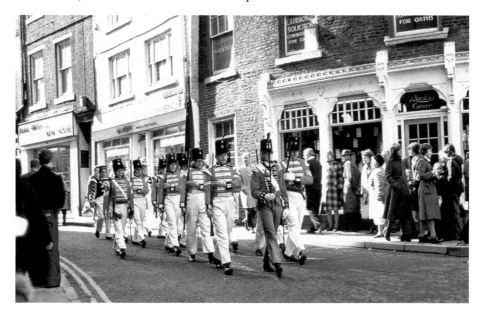

The old Durham Light Infantry Society and Display Team, 1970s, photographed entering the Market Place from Saddler Street. Note the shop on the right with the 'Rocket Corner' lettering above the door, named after a brand of shirt. The society was created in 1975 to keep the memory of the DLI alive.

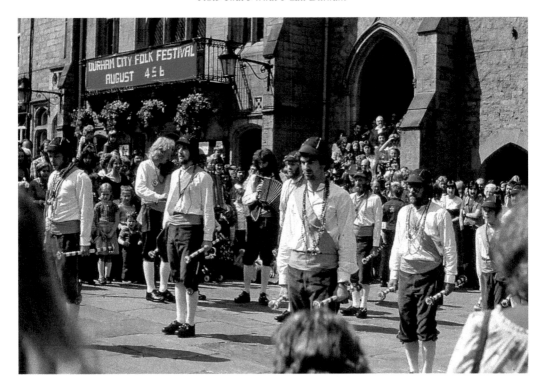

Above and below: Morris dancers in the Market Place during Durham City Folk Festival, 1978, a tradition that is still carried on in Durham today. One family of spectators make themselves comfortable watching the Morris dancers. It must have been a busy event – note the overflowing waste bins. (Both taken by J. K. Willis)

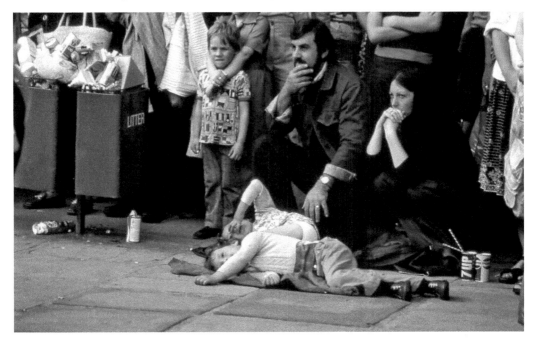

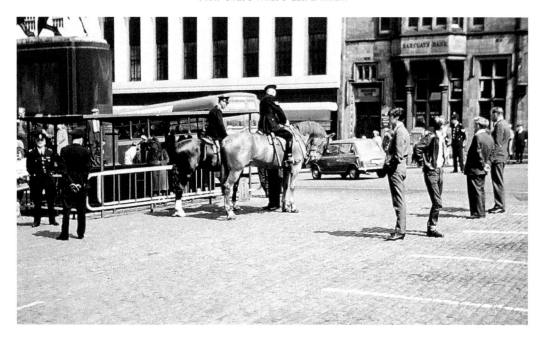

The Market Place showing two mounted policemen prior to Mayor's Sunday, May 1964. Note the bus stands on the left. That year Councillor Norman Sarsfield was elected. (Taken by Janet Thackray)

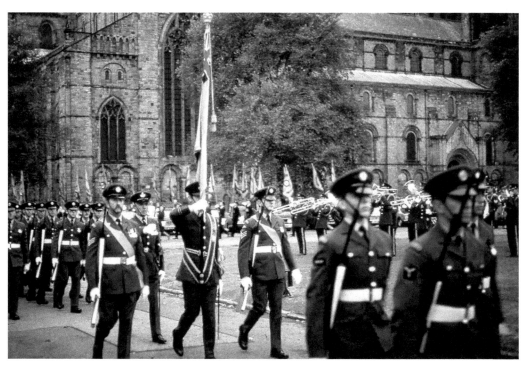

A Royal Air Force parade on Palace Green, possibly taken in 1970 to commemorate the thirtieth anniversary of the Battle of Britain in 1940.

Above and below: The royal visit of Queen Elizabeth and the Duke of Edinburgh, June 1977. The royal couple are pictured on the balcony of the Town Hall. The mayor that year was Councillor Alan Thompson.

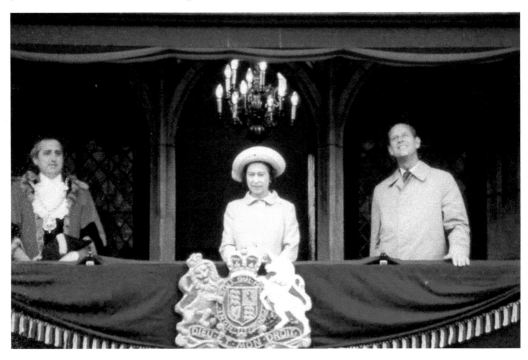

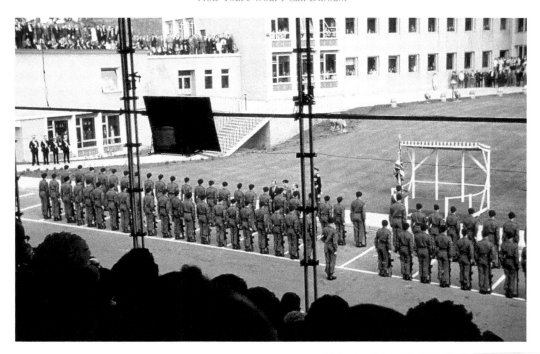

The official opening of Durham County Hall by the Duke of Edinburgh, 14 October 1963. The Queen was due to attend but was expecting Prince Edward at the time. Soldiers of the 8th Battalion, Durham Light Infantry, provided the Guard of Honour.

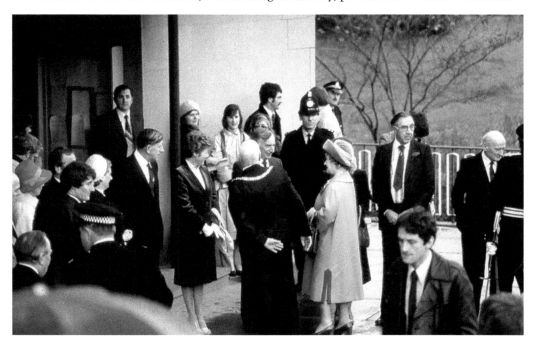

The Queen Mother visiting County Hall, 6 November 1980. She also visited Durham Town Hall the same day.

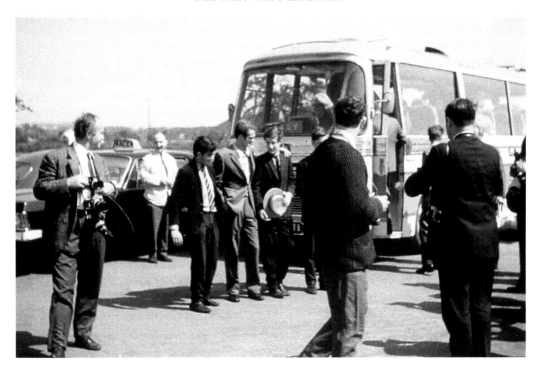

Above and below: The Italian football team at Houghall during the football World Cup tournament, 1966. Sadly for them, they were defeated by North Korea 1-0. The Italian team left Houghall for a match at Newcastle. The bus is a Phantom Panorama from Armstrong's of Westerhope and the car (below) is a Vauxhall Cresta.

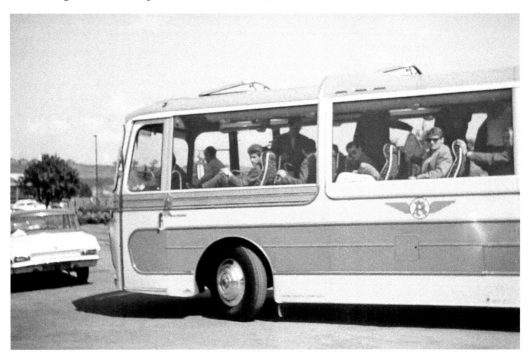

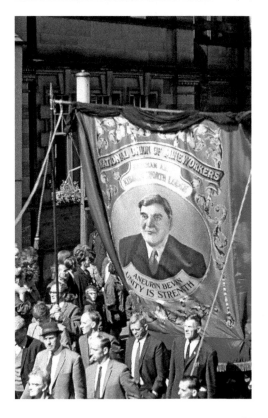

Durham Miners' Gala, showing the Wheatley Hill lodge banner on The Racecourse, early 1970s. The banner carries the portrait of Peter Lee, miners' leader, county councillor and Methodist local preacher (1864–1935). The banner behind it is from Lumley.

Durham Miners' Gala. A banner from Kimblesworth Lodge passes Old Shire Hall, Old Elvet, 1971. It has the portrait of Aneurin Bevin and is draped in black to signify a death in the colliery since the last gala.

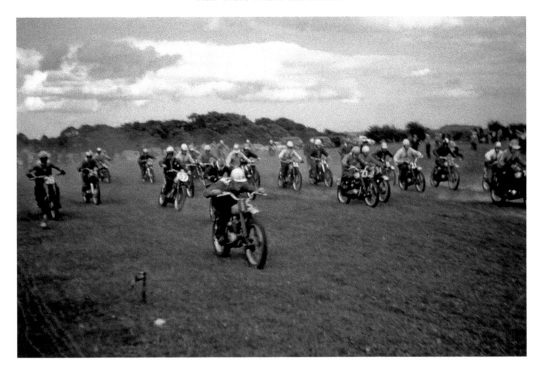

Above and below: 'At the starting line', Belmont Motor Cycle Scrambles, 1960s. It was such a popular event that it was occasionally televised. The photograph below shows the rough terrain and dust clouds of Belmont Scrambles.

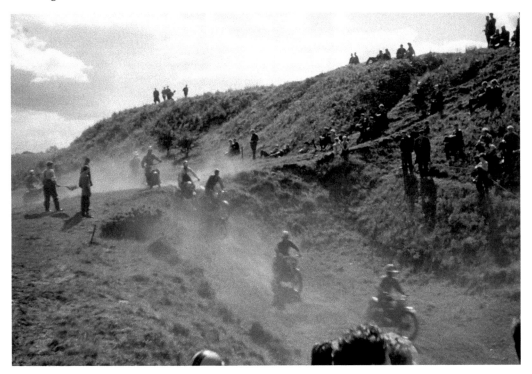

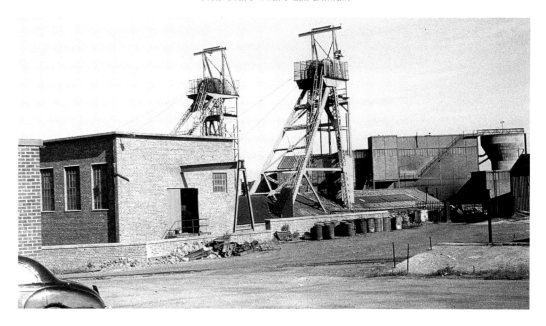

The winding gear of Sherburn Hill Colliery, *c.* 1960. The rear of the car to the left looks to be a Wolsey 444. (Taken by Billy Longstaff)

Two employees of Sherburn Hill Colliery, *c.* 1960. The man with the glasses is Tom Holmes from Pittington, who lived in Sherburn and lost a leg at sixteen in a pit accident. He moved to Pontefract in around 1963–64 with his wife Maggie and children Ken and Royston, when the pit closed. The other chap is Billy Luke. (Taken by Billy Longstaff)

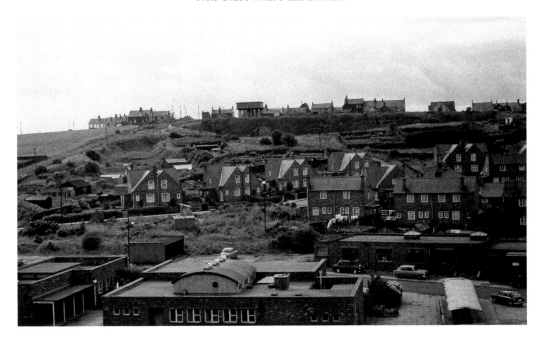

Looking over the rooftops of Kell Crescent towards the top of Sherburn Hill, *c.* 1960. The street was named after Councillor G. P. Kell and built in 1932. The large square building in the centre skyline is the old water tower. The photographer, Billy Longstaff, was at the top of the winding gear when he took this image.

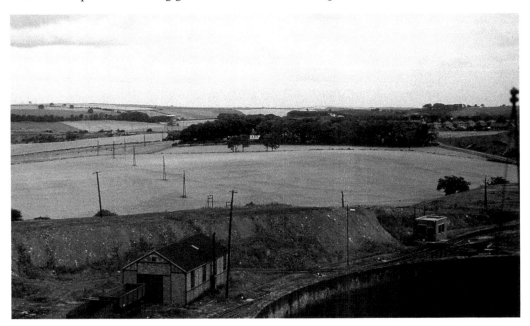

Another view from the winding gear looking towards Littletown, *c.* 1960. In among the trees is Littletown House and to the far right are the council houses of Plantation Avenue. (Taken by Billy Longstaff)

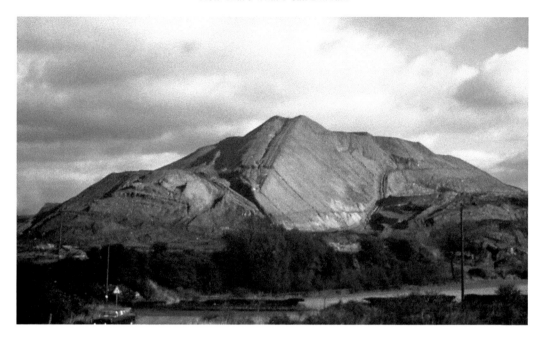

The massive Sherburn Hill pit heap, *c.* 1960. It took three years to lower it to around half the size, work which started in 1969. The car looks to be an Austin Cambridge. The site is unrecognisable today and is grazing farmland.

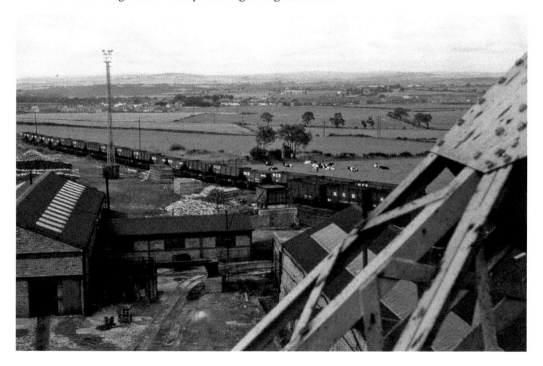

Looking towards Sherburn Village from the colliery head gear, showing the busy colliery yard with what looks like stacks of wooden pit props, *c.* 1960. (Taken by Billy Longstaff)

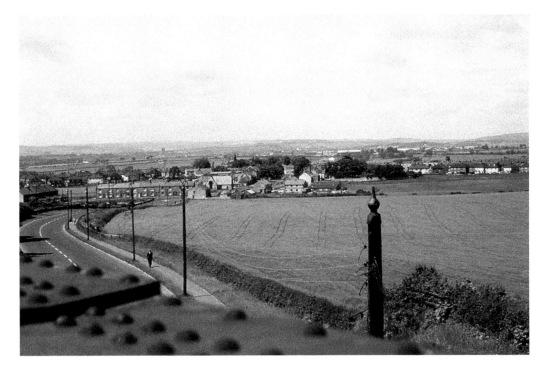

Above and below: A view looking towards Sherburn village from the bridge at the bottom of Local Avenue, *c*. 1960. The photograph below shows a similar view from the moors. Across on the right side of the second photograph are the allotments. (Taken by Billy Longstaff)

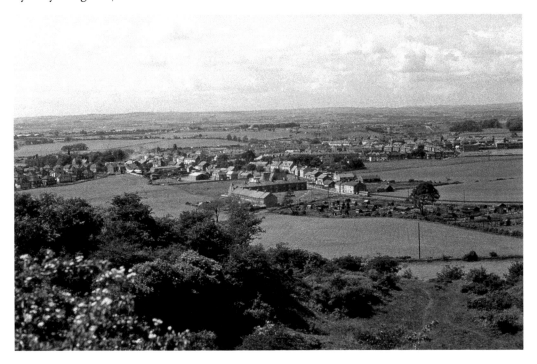

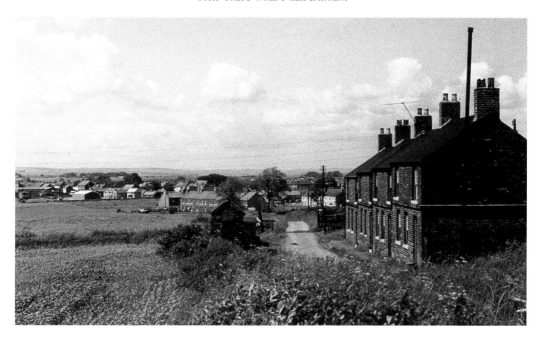

Above and below: Quarry Cottages on the track leading from the moors towards Sherburn Village, *c.* 1960. They had the head of a ram on either gable end, which was part of the family crest of the Lambton family, the colliery owners. They had only one entrance door, two bedrooms and no bathroom. The toilets were on the other side of the road in pairs with coalhouses in between. The photograph below shows Quarry Cottages from the Sherburn House Colliery line. The start of Sherburn Hill Moors is on the right. (Both taken by Billy Longstaff)

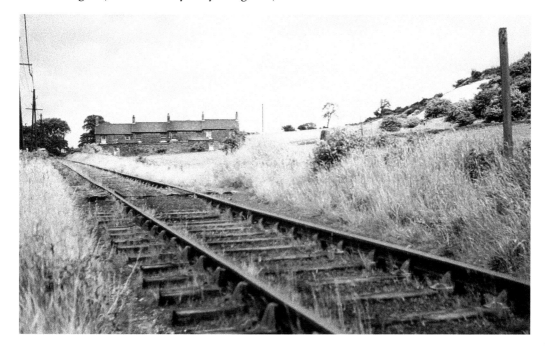

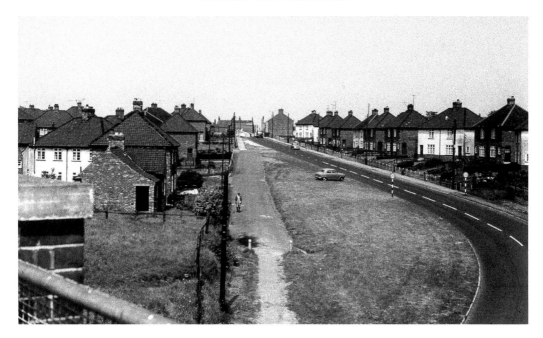

A view from Mill Lane Bridge, Sherburn Village, showing part of The Crescent on the left and Mill Lane on the right, *c*. 1960. The car in the foreground looks like an Austin Cambridge A55. (Taken by Billy Longstaff)

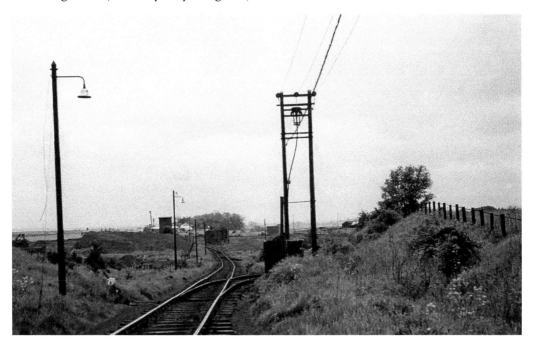

Along the lines looking towards the site of Sherburn House Colliery and Grand View council houses, *c*. 1960. The area, known locally as 'the bash', is now a pleasant walkway. (Taken by Billy Longstaff)

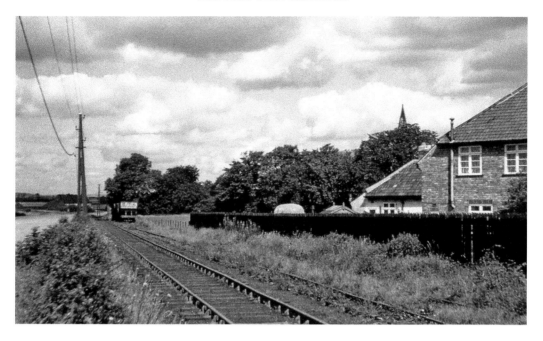

The railway line behind The Crescent and St Mary's Church heading towards Sherburn Colliery Station, *c.* 1960. (Taken by Billy Longstaff)

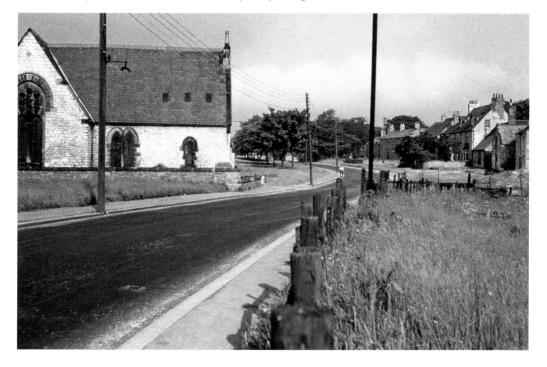

The old Wesleyan Chapel on the east side of the village, *c.* 1960, built in 1857 and enlarged in 1884. The site is now partly occupied by Chapel Court bungalows. (Taken by Billy Longstaff)

The old stables belonging to Sherburn Hall, *c.* 1960. These were situated on the site of the present Working Men's Club over the road from the former hall. (Taken by Billy Longstaff)

Robinson's Farm, Front Street, Sherburn Village, *c.* 1960. Although the building is now demolished, part of the wall and gate supports survive. A row of houses named Alston Walk was later built on the site. (Taken by Billy Longstaff)

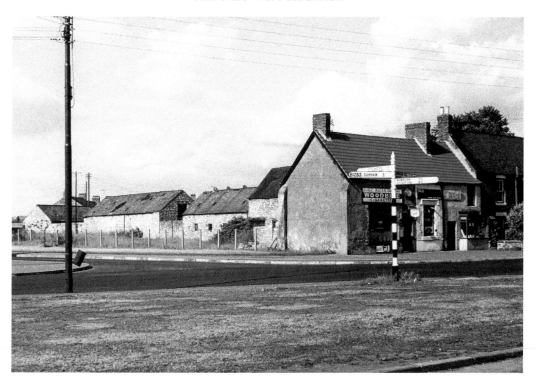

The crossroads, Sherburn Village, *c.* 1960. The outbuildings belonging to Lawson's Farm are shown. The shops on the right are Allan's sweet shop, Dicky Wilson's barbers and a DIY shop. (Taken by Billy Longstaff)

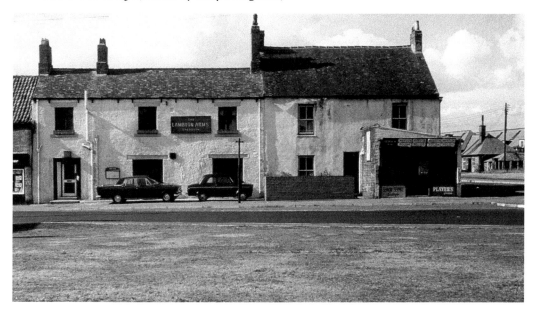

The Lambton Arms, Sherburn Village, *c.* 1960. The small shop on the right was Cairn's fruit and veg. (Taken by Billy Longstaff)

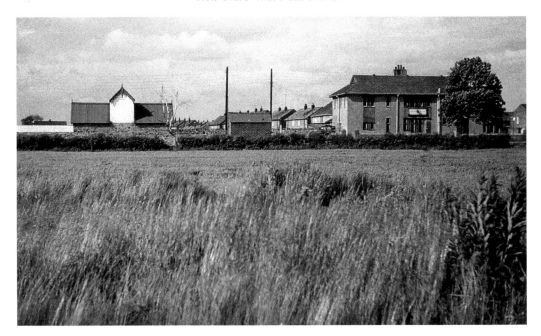

The large building on the right was Sherburn House Welfare, shown *c.* 1960. The two other buildings are the sports pavilion, and, in the centre, the old brick bus shelter. The houses in the background are in Kidd Avenue. (Taken by Billy Longstaff)

A view from Mill Lane Bridge looking towards Grand View shortly after the new road was laid, *c.* 1960. Note the old road leading off to the right. The area on the right of the picture was the site of Sherburn House Mill. The truck is a Bedford TK. (Taken by Billy Longstaff)